IMAGES
of America

SAN DIEGO
COUNTY PARKS
OVER 100 YEARS

The County of San Diego Department of Parks and Recreation followed in the footsteps of iconic park systems, including Golden Gate National Parks, by creating striking logos for its parks, preserves, community centers, and historic sites. A branding campaign with the first logos launched in 2015. (Courtesy of the County of San Diego Department of Parks and Recreation History Center.)

ON THE COVER: Picnics (called "pic-nics" by early residents), such as this expedition to Flinn Springs around 1915, have long been a San Diego tradition. Once a private resort, Flinn Springs County Park remains a popular spot for family gatherings and special events in the backcountry. (Courtesy of the San Diego History Center.)

IMAGES
of America

SAN DIEGO
COUNTY PARKS
OVER 100 YEARS

Ellen L. Sweet and Jennifer A. Grahlman
Foreword by Brian Albright

ARCADIA
PUBLISHING

Published by Arcadia Publishing
Charleston, South Carolina

Printed in the United States of America

Library of Congress Control Number: 2017936376

For all general information, please contact Arcadia Publishing:
Telephone 843-853-2070
Fax 843-853-0044
E-mail sales@arcadiapublishing.com
For customer service and orders:
Toll-Free 1-888-313-2665

Visit us on the Internet at www.arcadiapublishing.com

*This book is dedicated to parkgoers, park caretakers,
and future generations of park stewards.*

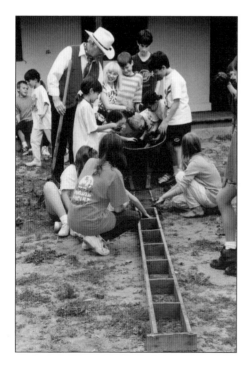

The County of San Diego Parks and Recreation Department offers special programs for individuals and families throughout the county. Here, children learn about adobe brick making at Rancho Guajome with the help of a volunteer docent. (Courtesy of the County of San Diego Department of Parks and Recreation History Center.)

CONTENTS

ACKNOWLEDGMENTS

The authors thank the County of San Diego Department of Parks and Recreation, especially Director Brian Albright, for sponsoring and contributing to this publication.

Photographs used in this book, unless otherwise noted, are from the County of San Diego Department of Parks and Recreation History Center. Many other photographs used in this book are from the extensive collections of the San Diego History Center (SDHC), and we appreciate the help of their professionals Chris Travers, Carol Myers, Natalie Fiocre, and Jane Kenealy. Other institutions and individuals also provided photographs, including Alice Funk of the Ramona Pioneer Historical Society (RPHS); Richard Crawford, Special Collections, San Diego Public Library (SDPL); Helix Water District (HWD); Grand Rapids Public Library (GR); David Lewis, Julian Historical Society (Julian); Richard Bumann (RB); Donna Shelton (DS); Linda Ralphs Kaeser (LRK); Steven Apple (SA); Paul Nestor (PN); William Woolman (WW); and Susan Baker Guthrie (Baker). We thank Michelle Peralta of the Escondido Public Library Pioneer Room, Richard Moore of the Solana Beach Civic and Historical Society, and Jack Larrimer of the Vista Historical Society for searching their collections for photographs. Christopher Wray's extensive knowledge of the San Diego Flume was very helpful.

Rangers, office staff, and retired members of San Diego County Parks and Recreation assisted and supported us. We are extremely grateful to Jacob Enriquez and Cailín Hunsaker for their guidance and love of history. Cheryl Wegner, Mary Niez, John DeWitt, Susan Hector, Maureen Abare-Laudy, Paul Kucharczyk, Melvin Sweet, and Gloria Hinkley provided information and assistance. Vincent Freeman produced the current county map. We thank the board of the San Diego County Parks Society for their encouragement.

Lastly, we are indebted to the two historians, the late Mary F. Ward and Dr. Lynne (Christenson) Newell, whose research and files have done so much to preserve our department's history.

FOREWORD

At the far southern end of California, along the shared, sunny border with Mexico, lies San Diego County. A pastoral region of ranches and small towns for most of the 1800s, the county would eventually boast one of the largest and most diverse parks and recreation departments in the nation. Spurred by the efforts of philanthropic citizens, the County of San Diego Department of Parks and Recreation began as the 20th century unfolded. In towns such as Ramona, Lakeside, and Spring Valley, San Diego County's first parks were community cornerstones. Soon afterward, picturesque groves, vales, and desert refuges where citizens had gathered to picnic for decades also became county parks. Beach-access land was acquired by the County of San Diego, and lifeguards were charged with protecting the public. To meet the needs of a growing postwar population, San Diego County built large regional parks and campgrounds, where both longtime and new San Diego families could recreate and enjoy the county's natural offerings. Preserving these sensitive waterways, beautiful vistas, and remarkable biodiversity—as well as the region's historical character—remained key as San Diego County blossomed into a thriving region of major cities and planned communities. Today, San Diego County Parks and Recreation serves more than 40 communities with its over-50,000-acre system of 125 sites including local parks, sports complexes, nature centers, ecological preserves, historic parks, trails, fishing lakes, botanical gardens, community and recreation centers, skate parks, and open-space preserves. A pride of the region, San Diego County Parks and Recreation demonstrates that nothing quite reflects the essence of its citizens like a community's parks. The photographs included in this book show not only San Diegans truly enjoying county parks, but also the steadfast efforts of a department committed to enhancing life in San Diego County. I am pleased to introduce this book on the history of some of our beloved parks.

—Brian Albright
Director
County of San Diego Department of Parks and Recreation

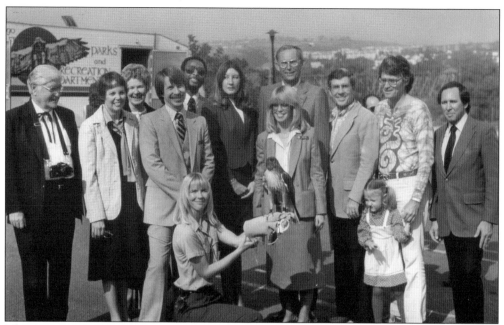

The County of San Diego Department of Parks and Recreation works with communities on beautification projects, cleanups, and environmental education, as these two photographs illustrate. In the photograph above, from the early 1980s, the San Diego County Parks Society, a nonprofit civic group, partners with the department to support community outreach using an "Ecovan." Fourth from left is Director Robert Copper, along with society members, staff, and ranger Lauren Hall-Cather with a red-tailed hawk. On March 8, 2014 (seen below), when Director Brian Albright (sixth from left) and County Supervisor Greg Cox (center) opened an observation deck at Hollister Pond in Otay Mesa, they concluded the efforts of multiple groups, namely the County of San Diego, the Cities of San Diego and Chula Vista, the California Conservation Corps (grouped at right), and citizen advisors.

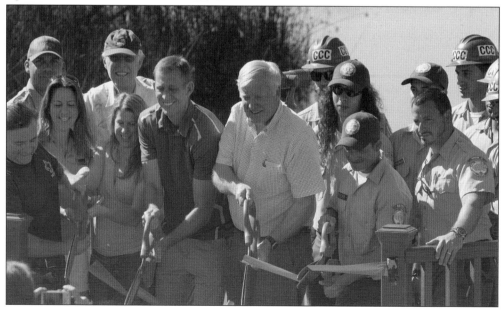

INTRODUCTION

In 1970, the County of San Diego Department of Parks and Recreation (DPR) published a bound inventory of its 45 parks with photographs and a short history of each. At that time, it was felt that the public would better appreciate their parks if the department provided historical background. This was the first effort to compile pertinent park information since Supervisor Walter Bellon's typescript report of 1944—before there was an official parks department. Bellon's report on park holdings was an effort to describe the properties and point out some of the unique assets in San Diego County.

While not all DPR parks have significant historic sites, they all have something of local historical interest. This book tells some of the stories, well known or obscure, that make the department's parks special. It also documents the early history of the County of San Diego parks system. Of necessity, not all county parks have been covered. Furthermore, some of the more-historic sites received extensive coverage in earlier DPR History Center books.

DPR history can be divided into four periods. The system of parks took shape from 1913 to 1946. From 1947 to 1960, the cooperation of civic groups and other agencies boosted growth and development. The department transitioned to purchasing regional parks and protecting environmental resources between 1960 and 1973. Finally, from 1974 to the present, emphasis moved to urban regional parks and the local-park classification.

Prior to the 1940s, the County of San Diego had no methodical program to obtain parks. Early parks owed their existence to civic-minded donors and to developers who donated parkland to enhance the quality of their residential subdivisions. The land for the earliest park still owned and operated by the County of San Diego came from David Collier in 1908. Collier County Park and additional early parks are presented in chapter one. With no official county parks department, the County of San Diego Road Department handled maintenance responsibilities. After 1938, when the County of San Diego Property Department was established, it assumed the operation and maintenance of all County of San Diego parks and worked to garner new park sites.

Parks originating through donations often varied immensely in size, and their locations were only moderately related to greater San Diego's population dispersion. The County of San Diego concluded that a recreation program was a desirable supplement to the attractive but increasingly remote environments of its parks. On August 19, 1946, an ordinance passed that made San Diego County one of the first counties in the nation to establish a "department of recreation." (Many city park systems existed, but counties were slower in organizing.) Cletus Gardner led this new department, and chapter two tells his story. The department began a number of countywide athletic programs, operated Gillespie Field gym and pool, gave talks to high-school students on sportsmanship, and identified and marked historical sites.

In addition to these new offerings, the Recreation Department inherited the Property Department's parks, with 10 narrow, bluff beaches between Del Mar and Bataquitos Lagoon among them. Chapter three relates a history of the beach parks. Though it operated the parks, Gardner's

department was reluctant to dilute its recreation program with maintenance and developmental responsibilities, which remained with the parks and beaches division of the County of San Diego Property Department (later renamed the Department of Public Works).

In 1947, the Recreation Department created the first girls' softball league to exist in the county in over 12 years. The league created tremendous interest, with "crowds [that] were several times larger than for the various men's leagues." County community centers offered classes in model-boat building and "listening to records" and hosted special events such as pet shows. Chapter four discusses community centers, community parks, and their recreation programs.

The late 1940s was not a time of many park donations or dedications. Demands for post–World War II housing dried up the well of developers' generosity. To compensate, the County of San Diego strengthened its nexus of parks by collaborating with other public agencies and special districts. During the 1950s, this approach expanded as the county assumed responsibility for park acquisition and improvement programs begun by local civic organizations and nonprofit foundations that ran out of money, manpower, or both.

The Recreation Department was restructured into the Department of Parks and Recreation in 1957, and ranger staff transferred from the Public Works Department. While the responsibility for capital improvements and major maintenance remained with public works, uniting everyday maintenance and recreation functions in DPR set the stage for modern growth.

By the late 1950s, it was apparent that only relying on efforts initiated by others would not provide a quality network of parks—DPR needed to purchase land outright. Park planners set up an aggressive program that focused on larger regional parks, some of which appear in chapter five. Many of these bigger sites offered visitors the option of extending their stay in the outdoors; the first true campground owned and managed by DPR was added in 1967 with the procurement of William Heise County Park. It is described in chapter six, along with more camping parks. In this time of expansion, sites totaling thousands of acres joined the fold—including Wilderness Gardens County Preserve, a 595-acre area awash with camellias. Chapter seven outlines preservation efforts undertaken there and elsewhere. In 1972, Cletus Gardner retired and Lloyd Lowrey became the second DPR director.

DPR's acquisitions program began to pinpoint potential park sites and environmental-resource areas that were most threatened by the spread of urbanization. The two types of open space that were considered critical were large, urban park sites encompassing floodplains or water bodies and coastal lagoons, most notably San Elijo. San Elijo Lagoon Ecological Reserve has been significantly upgraded—pictures of this and other new park elements are featured in chapter eight.

From 1978 to 1982, County of San Diego cutbacks slashed DPR staff levels roughly 30 percent while the number of parks and the size of the workload increased by more than half. To avoid closing parks and denying service, DPR increased its use of unpaid staff nearly fourfold over the 1980s, accounting for almost half the department's labor. Despite these shortages, DPR built and maintained parks and community centers in nearly every community in the unincorporated areas of the county. When Lloyd Lowrey retired in 1982, Robert "Bob" Copper became the third director. He and subsequent directors Michael Kemp, Alex Martinez, Dr. Susan Hector, Renée Bahl, and Brian Albright kept DPR tracking in this direction.

The County of San Diego parks system now contains assets worth billions of dollars. Its facilities are used annually by over 12 million people from all 50 states and around the world. DPR programs and practices have been adopted by agencies throughout California, the United States, and seven other countries.

The introduction to the 1970 inventory still applies today: "No generation has been made more aware of the environment in which it lives, and the need is urgent to protect and preserve." In the face of 21st-century pressures and an increasingly technology-centered lifestyle, DPR's resources are even more important to a well-balanced society that safeguards its land, wildlife, and historical and archaeological treasures. The authors hope this history of San Diego County parks will foster even greater appreciation of the DPR park system.

One

EARLIEST PARKS, 1913–1946

Widespread public commitment toward making land and park facilities available to present and future generations began in San Diego County more than 100 years ago. Ramona became the site of the first County of San Diego park when community booster David Charles Collier donated land on the condition that citizens took responsibility for improving it. Collier County Park dates back to 1913. Other smaller parks such as Goodland Acres followed as donations from land developers.

Three major picnic facilities in outstanding natural settings were acquired in the 1920s. Lindo Lake and El Monte County Parks in Lakeside and Live Oak County Park in Fallbrook remain major facilities with high public use. This chapter highlights these parks and also the history of Cactus County Park in Lakeside, Eucalyptus County Park in the Spring Valley area, and the historic Campo Stone Store.

The time period documented in this chapter was marked with strong park usage for picnicking and for camping as automobiles became popular. Enthusiasm was inspired by the Camp Cajon model, which was established between 1919 and 1921 in San Bernardino Valley. Cookstoves and round concrete tables with accompanying benches were erected to attract the motoring public. Fraternal and community organizations sponsored tables featuring central medallion plaques. San Diegans embraced this model and added concrete tables to some of their earliest parks.

In the 1920s and 1930s, small beach parcels were added to the County of San Diego inventory as the Great Depression brought in donations of oceanfront-subdivision parcels in Del Mar, Solana Beach, and Encinitas. In all, a total of 10 park sites were added during the 1920s, with most during the boom period of 1928 and 1929.

There were few financial resources and no formal plan to provide infrastructure for large sites during this pre-1946 time period. An early report summarized the holdings of County of San Diego parks as totaling more than 650 acres with less than $10,000 spent to obtain the land.

Developer and lawyer Col. David Charles Collier encouraged the beautification of Ramona and offered land for a public park in 1908 on the condition that an improvement club act as sponsor. The land was deeded to the Ramona Improvement Society. Luther Janeway, president, and F.A. Creelman, secretary, deeded the land to county government in November 1913, making it the first County of San Diego park.

Back Country Day in Ramona, August 1915, celebrated the dedication and renaming of the municipal park to honor Colonel Collier, who was in attendance. A parade, literary exercises, sports, speeches, and a US Marine band concert were part of the entertainment which drew 5,000 people from all over the county. At nearby Van Loon grove, pictured below, a free barbecue attracted lines of hungry people. (SDHC.)

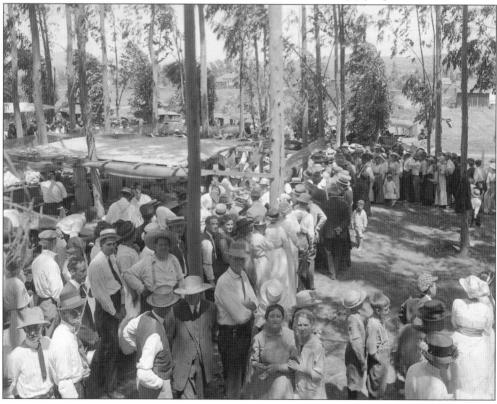

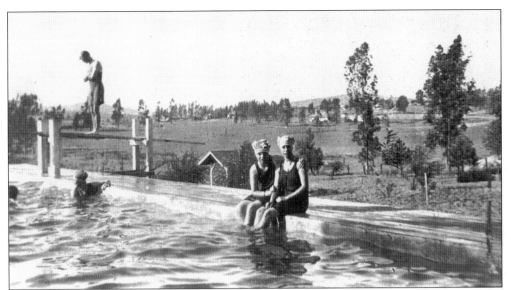

Collier Park was the first in the county to have a swimming pool with dressing rooms for adults and children. As early as 1920, the concrete pool was located on the park's west side and filled in the summer with river water. Here, two swimmers pose on the side of the pool in 1926. Over the years, the pool experienced closures due to cracking and water shortage. It was finally closed and removed. (RPHS.)

The Boy Scout hut in Collier Park had its cornerstone placed on July 4, 1925, with the farm bureau sponsoring the project. At the dedication, Mesa Grande and Santa Ysabel Indians demonstrated games and dances. This hut was also used by community groups, as a voting site, and by the California State Militia. Arson destroyed the scout hut in 1997, and a new one was built the following year.

A bandstand was dedicated in Collier Park in July 1927. It was used extensively for entertainment at the Ramona Turkey Day programs from 1933 to 1941, which included a ceremony to crown a queen, variety shows, dancers, acrobatics, jugglers, magicians, acts with trained dogs and mules, soloists, and concerts. This photograph depicts the band shell about 1941.

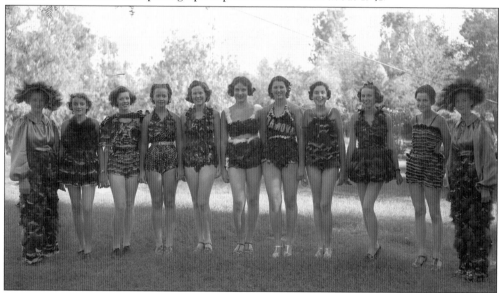

Collier Park was a centerpiece for Ramona's celebrated Turkey Days, which specialized in a bathing-beauty contest with costumes made of turkey feathers. Some Turkey Days drew as many as 25,000 people countywide, with special trains transporting them to the depot at Foster and cars that took them the rest of the way to Ramona. The 1936 and 1937 programs featured an airplane stunt dropping turkey sandwiches from the sky. (SDHC.)

Elinor Smith of Ramona High School was crowned queen of Turkey Day 1939 by California legislator Ed Fletcher. Here, she poses with "King Gobbler" for a press photograph. Queen Elinor led the event's parade, riding in the Warner Hot Springs stagecoach down Main Street. That year, 100 fortunate visitors were given prime Ramona turkeys.

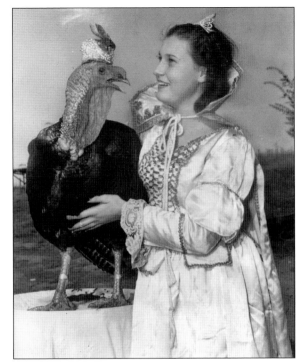

This 1970 photograph of Collier Park features the tennis court, swings, and Works Progress Administration rockwork. The Collier rockwork was part of a nine-block Ramona drainage project to put citizens to work. Local people labored for $1 per day, competing to see who could lay the most feet. The project remains in good condition and is eligible for the National Register of Historic Places.

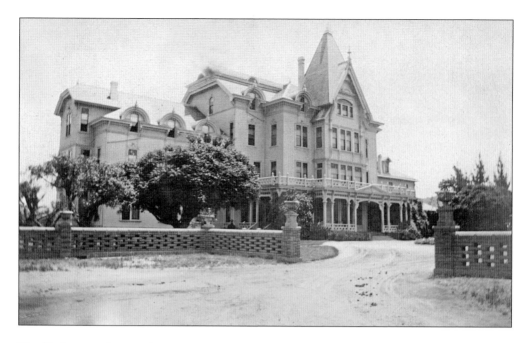

The El Cajon Valley Land Company constructed the beautiful, Victorian Lakeside Inn in 1887. The previous year, the company dedicated 45 acres, featuring a small natural lake named Lindo Lake, as a public park near the future inn. A boathouse was also built to attract tourists. Hotel guests and locals enjoyed boating and picnicking until John H. Gay bought the Lakeside Inn in 1904, fencing the park and claiming all the land. Townspeople were upset that they were excluded from the park and petitioned the county to reclaim use of the land and the lake. After a protracted court case, the park land was re-declared County of San Diego property in 1921. During litigation, the hotel sat idle until it was torn down in 1920.

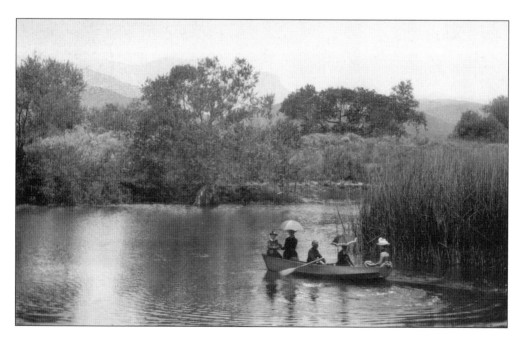

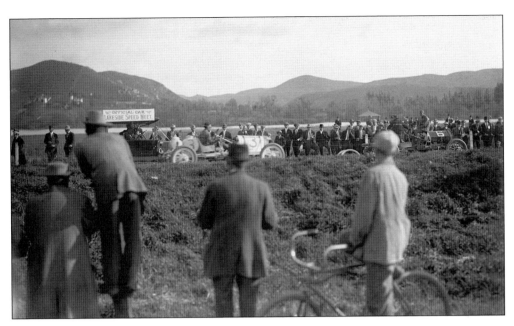

Adding to his resort, John Gay built a two-mile oval automobile racetrack around Lindo Lake. The first races took place in April 1907 and were highly advertised with popular driver Barney Oldfield racing against a tough competitor: "Flying Dutchman" Bruno Siebel. Special train service was instituted to bring huge crowds to the track. Oldfield, as seen below, drove his "Green Dragon" in the featured race. Newspaper headlines in San Diego proclaimed, "Oldfield beats world's record . . . at Lakeside track." The photograph above captures visitors lining the track about 1912. (Above, SDHC.)

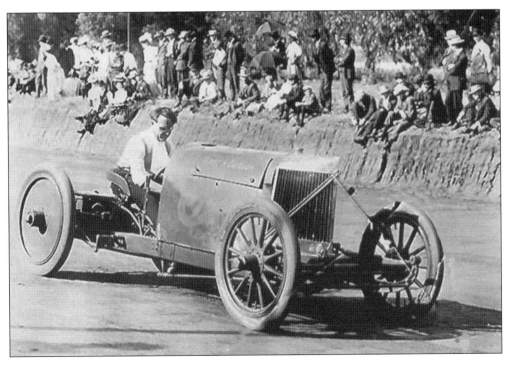

Lindo Lake Park is a popular San Diego County park—and one of the oldest. It is an integral part of the community of Lakeside, and its citizens have taken an active role in using, improving, protecting, and advocating for it. The boathouse, constructed to sit on pilings with a footbridge connecting to the shore, is a California Point of Historical Interest. In 1965, the boathouse was moved out of the lake and the footbridge was destroyed. In 1977, an artificial island was created in the lake for the boathouse, and a new walkway was built linking the shore to the island. The lake and boathouse are pictured during two time periods, the early 1940s (above) and 1975.

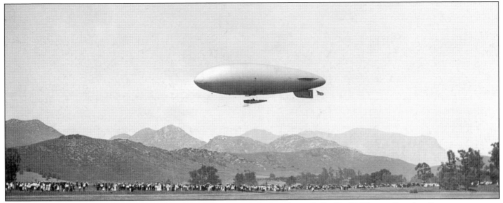

The formal opening of Lindo Lake Park was celebrated on July 5, 1920, with a barbecue, sports, horseback potato polo, bronco-busting, an all-night dance, an encampment of indigenous people, music, fireworks, and a dirigible from North Island. As revealed in this photograph, the US Navy blimp B-18 delighted the big crowds and was even moored to special concrete blocks while the crew participated in the celebration. (SDHC.)

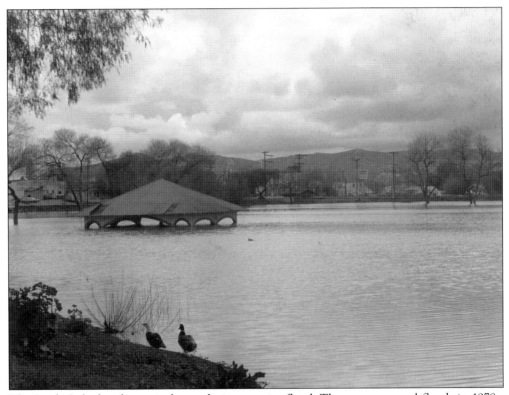

The Lindo Lake boathouse is shown during a major flood. There were several floods in 1978–1980, with water reaching the boathouse roof. Keeping lake water stable has been a challenge. Drought in the 1940s left the lakebed dry. The building of a dam across Quail Creek upstream blocked the principal water source for this natural lake, which was once used by Kumeyaays as a camping site.

Live Oak County Park, located in northern San Diego County, is in a valley filled with old-growth coast live oak trees. Luiseño and Juaneño families found the area attractive for settlement. Large outcrops display the remains of multiple *morteros*, or grinding rocks, overlooking the streambed. Acorn-, plant-, and seed-grinding activities took place in this "kitchen."

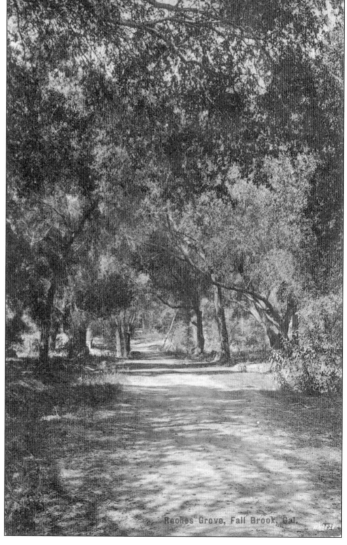

Reches Grove, Fall Brook, Cal.

In 1869, Vital and Anthony Reche settled in the area between Ranchos Santa Margarita and Monserrate. They called their land Fall Brook after an area in Pennsylvania. This 1909 postcard of Reche's Grove (now Live Oak Park) preserved the note, "Doesn't this look like a pretty place for an auto drive?" Reche's Grove was popular for family outings and church and school picnics long before it was designated a park.

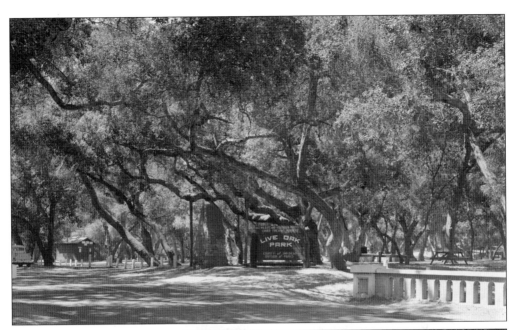

Preservation of Reche's Grove for all to enjoy involved the Reche family, the Denver O. Lamb family, Eric Hindorff, George W. Houk, and the Chamber of Commerce of Northern San Diego County. Efforts to formally preserve the land started in 1917. The Lambs purchased a grove of oaks specifically to save the trees in the face of development. Houk, a wire-wheel magnate and president of the chamber, donated money and offered matching funds to be used for parkland acquisition. Lamb's son-in-law Hindorff was responsible for many of the park improvements. The photograph above depicts the park's entrance and monument around 1953. The photograph at right gives a closer view of the same monument, which lists the park's 1920 dedication date. The County of San Diego acquired the park in 1925. (Above, SDHC.)

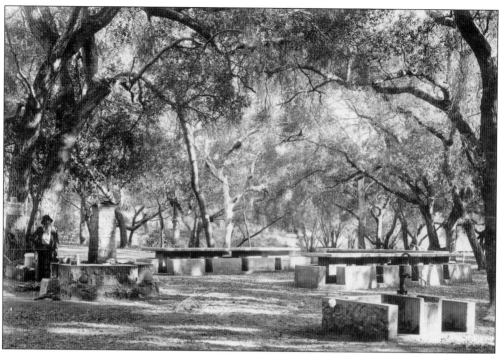

The same picnic area in Live Oak Park is presented in 1922 (above) and around 1990. In the early years, D.O. Lamb was custodian of the park. Lamb, Hindorff, and others admired William Bristol's Camp Cajon campground and welcome station for motorists in Cajon Pass and emulated Bristol's patterns for picnic tables, benches, and fireplaces. Money for cement tables was pledged by communities, families, and organizations. Each table and fireplace made by Hindorff, a skilled craftsman, featured a donation plaque. The large historical fireplace to the left in both photographs was made of cement and stone from the granite quarries in the Rainbow Mountains. Its plaque reads, "12 Miles North Temecula/Murrieta Hot Springs 17 Miles North." Bristol headlined Live Oak Park's dedication on July 4, 1920.

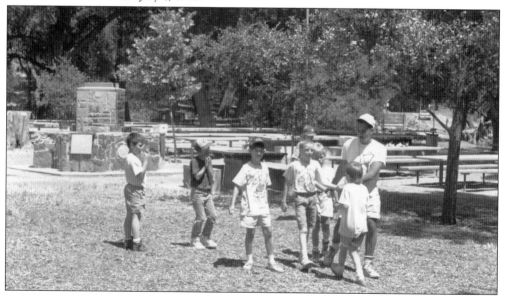

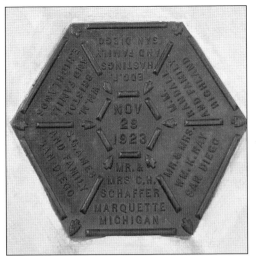 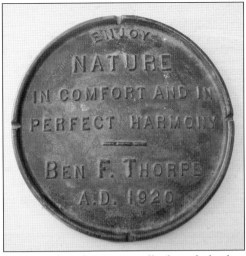

These are two of the bronze table plaques placed at Live Oak Park. Hexagonally shaped, the first plaque honors six families. Ben F. Thorpe, president of the Chamber of Commerce of Northern San Diego County during the park's dedication and early development, gave the plaque on the right. The significance of the Live Oak Park tables, benches, cookstove, monument, and guest register has been recognized with historic designation by the county historic site board.

The Live Oak Park store, with its gas pump and "groceries" sign, is pictured here in 1941. The original store was built of logs by Eric Hindorff in the early 1920s. He and his wife, Pearl, operated the concession for automobile campers and picnickers, charging 25¢ a night. In the 1930s, the park was changed to day use only.

Lakeside's El Monte Oaks, with its backdrop of majestic El Cajon Mountain, had been a popular camping and picnic area since the 1880s. The San Diego Floral Association, including members George Marston, Hugo Klauber, and William Templeton Johnson, proposed purchasing the land for a park. The county board of supervisors agreed in 1920. The El Monte Ranch Company sold the land to the floral association until such time as the County of San Diego could appropriate the money.

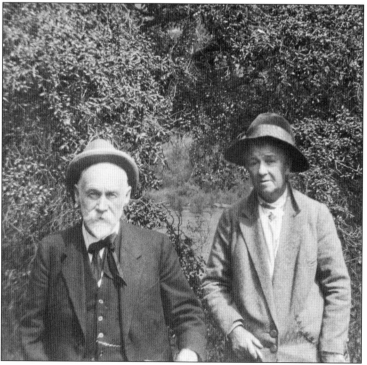

The floral association provided a small store, caretaker's residence, and restrooms. It paid for maintenance and a caretaker until El Monte was turned over to the county. Horticulturalist Kate Sessions (right) visited El Monte County Park in 1926 with Swiss rock-garden authority Henri Correvon. They thought that El Monte's rocky hillsides could be made into a European-style rock garden—a plan that never materialized. (SDHC.)

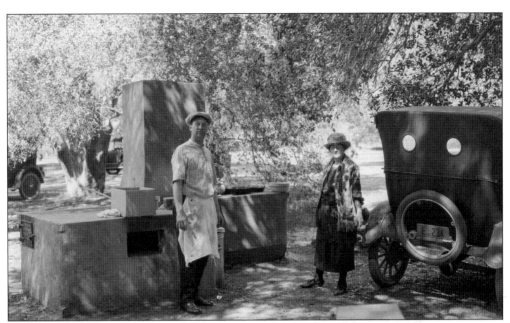

El Monte, like Live Oak, had picnic facilities modeled after those at Camp Cajon. In the above photograph, from 1925, picnickers utilize the fireplace under the park's majestic oaks. Concrete tables with benches, sponsored by local residents and fraternal groups such as the Nomads of Avrudaka, were additional amenities. Julius Vanoni, early park caretaker, donated the first table in 1924. The table plaques pictured at right list some additional donors. The Foster and Ames families helped with the table construction. In 1925, the Native Sons and Daughters of the Golden West erected a 65-foot flagpole, donated by Benson Lumber Company, during their annual picnic. (Above, SDHC.)

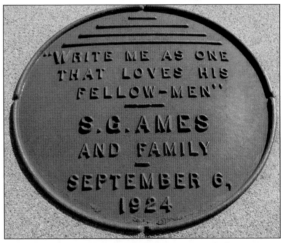

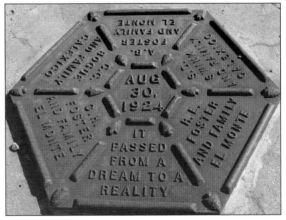

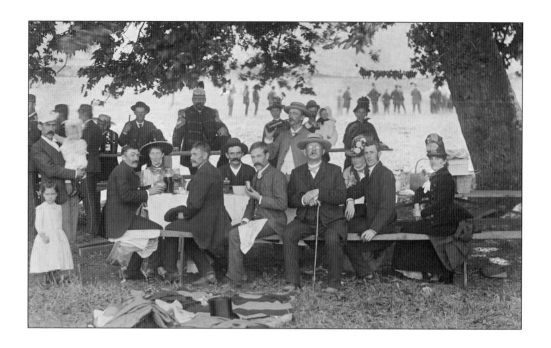

Considered the county's picnic ground, El Monte Park provided a wonderful outdoor experience. The photograph above, taken around 1887, portrays women wearing voluminous ankle-length outfits and fancy hats for nature walks and picnics. Men also wore formal attire. The bottom photograph captures some of the 2,000 parish members attending the 1926 picnic of Our Lady of the Rosary Church. They celebrated Mass, ate a lunch of ravioli and barbequed meat, and ran races. Some attendees competed in tug-of-war and egg-and-spoon races. Music, singing, and dancing provided additional entertainment. Other groups that held annual picnics or were hosted at the park included the Elks, Modern Woodmen of America, children from orphanages, seniors from Edgemoor Farm, and, especially, the County of San Diego employees' association. County employees contributed money toward building more picnic tables at El Monte. (Both, SDHC.)

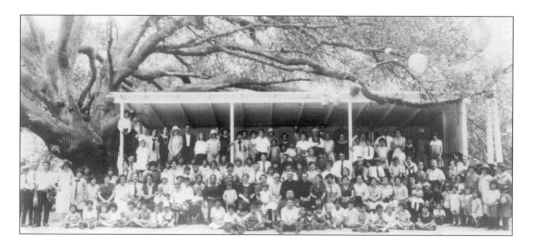

During World War II, the US Army leased one half of El Monte Park to train men in mountain climbing and survival. Nearby Lindo Lake Park served as a base camp for two companies of the 160th Infantry, which manned antiaircraft guns protecting El Capitan Dam. As these two photographs from the 1940s illustrate, El Monte Park was the site of organized dances, picnics, and barbecues to honor and entertain the military and civilian workers.

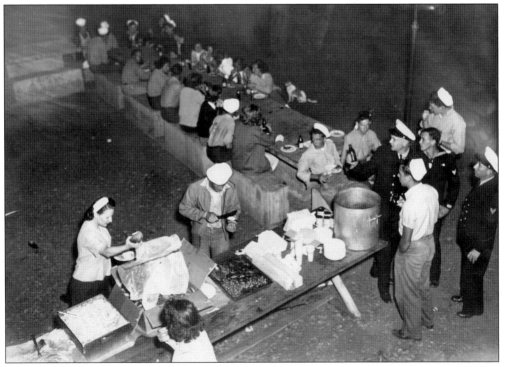

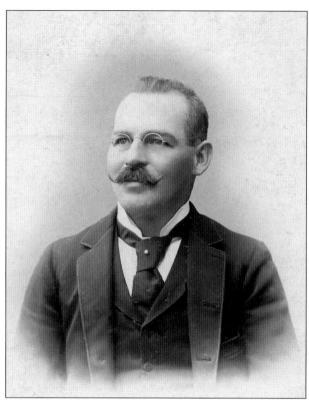

In the 1880s, William Thum, a druggist in Grand Rapids, Michigan, challenged his sons Otto, Hugo, William, and Ferdinand to invent something to rid the town of the pervasive flies that came from the use of horse-drawn transportation. The result was a sticky flypaper, patented in 1887, which made the Thums wealthy. Subsequently, Hugo Thum, pictured at left, and his brothers came to Southern California. Purchasing land in the Lakeside area, Hugo Thum experimented with growing spineless cactus for agricultural purposes and cattle feed, as revealed in the 1915 image below. It was his cactus ranch that eventually became Cactus County Park. (Left, GRPL; below, SDHC.)

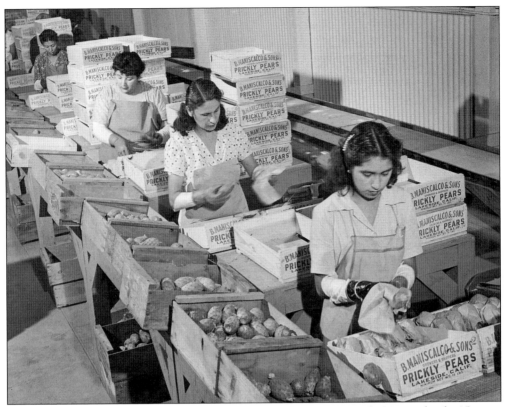

Before his death in 1923, Hugo Thum leased his cactus ranch to Bernardo Maniscalco for 15 years. Maniscalco cultivated 40 acres of prickly pear cactus for its fruit, sending eight carloads annually to New York, where Sicilians and Italians considered it a delicacy. Maniscalco workers, depicted above, packed the crop. Pictured below in the early 1940s are the remains of a packing shed. As part of Hugo's bequest, William and Margaret Thum deeded 114 acres to the County of San Diego. On July 16, 1928, Ed Fletcher presented the park to the county on behalf of the Thums. In 1958, fifty acres of the parkland were transferred to the Grossmont High School District for El Capitan High School. (Above, SDHC.)

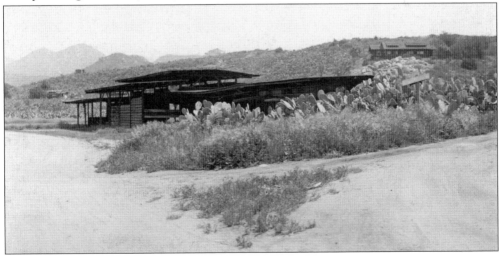

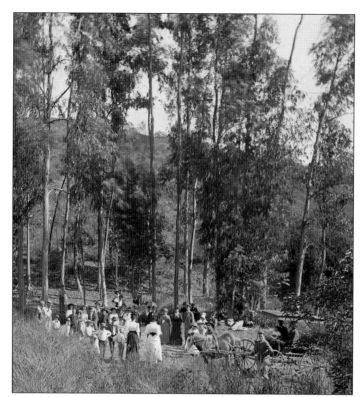

Eucalyptus trees planted by settler Charles S. Crosby provided a community picnic area called "the Grove" in Eucalyptus Canyon for residents of Spring Valley and La Mesa. Crosby planted seeds from Australia and then transplanted the seedlings to the canyon. Originally planted as a cash crop for railroad ties, the trees were unsuitable for that purpose. (SDHC.)

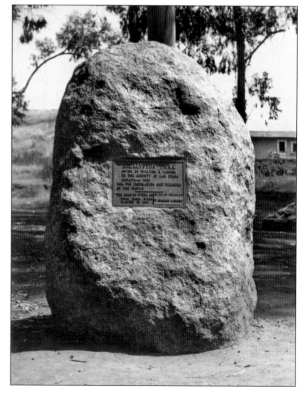

This monument placed at the dedication of Eucalyptus County Park states, "Given by Walter S. Lieber to the County of San Diego, Christmas 1929, for the inspiration and pleasure of the people. 'The groves were God's first temples.' These trees planted in 1880." The words "by Charles S. Crosby" were later appended to the plaque.

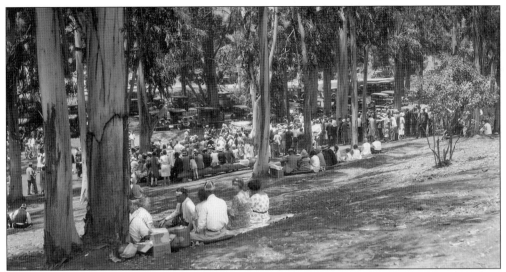

The dedication of Eucalyptus Park took place on July 4, 1930. The event started with a float parade from La Mesa to the park. Keynote speaker George Marston expressed trees' importance to society and, after the speeches, the throngs spread out their picnics. Children played games, ran races, watched a circus, and set off daytime fireworks. (SDHC.)

This 1970 photograph of Eucalyptus Park reveals some of the drainage rockwork done by the Civilian Conservation Corps in the 1930s. Eucalyptus Park was one of several county parks where extensive public-work programs employed people during the Great Depression.

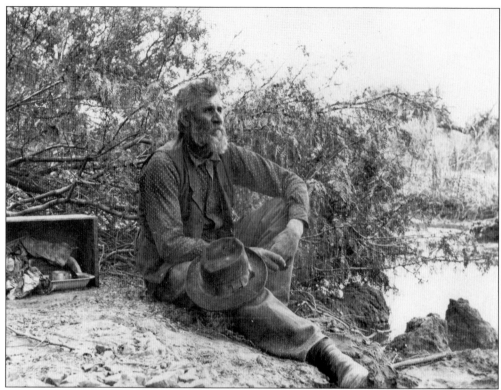

In 1868, brothers Luman (pictured above) and Silas Gaskill came to an area near the Mexican border called Milquatay Valley. A number of Texans had migrated there after the Civil War. The Gaskills established a village called Campo, illustrated below, consisting of a gristmill, blacksmith shop, store, and hotel. The Gaskill home is the two-story building in the center right. The wooden-frame general store, shown in the center, was owned by August Gass. Luman partnered with Gass, but disagreements led the Gaskills to buy out Gass in early 1875. Bandits from across the border attacked the Campo store in December 1875. The ensuing gun battle resulted in both Gaskills and several robbers being seriously wounded, at least one death, and a pair of hangings.

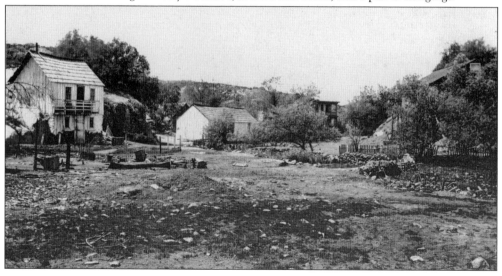

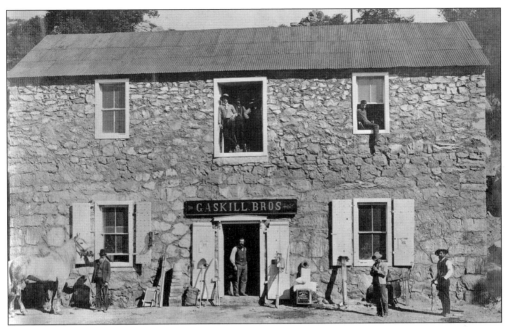

As a result of that 1875 gunfight, the Gaskill brothers built a stone store in Campo in 1885 to discourage future attacks and protect against future raids. The two-story store had four-foot-thick walls, heavy oak doors and shutters, and rifle slits. The above photograph captures the Gaskill Brothers Store about 1887. Below, the store was photographed about 1898. Luman Gaskill is on the far left. Over the years, the building functioned as a bank branch, supply center, stage station, and post office.

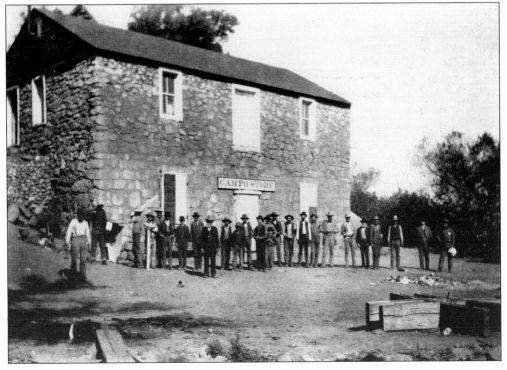

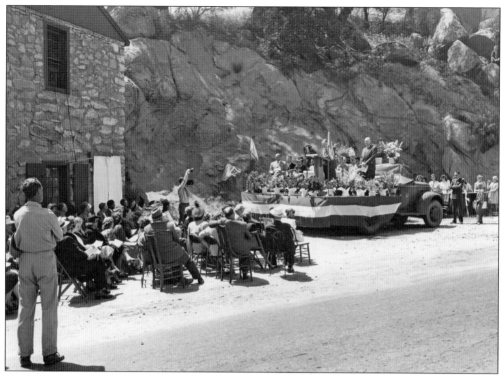

Ellsworth Morgan Statler, a member of the Statler-Hilton hotel family and a local rancher, bought the vacant stone building and handed the deed to the County of San Diego in July 1942. The building was rehabilitated through the efforts of the county and the US Army in 1944. During World War II, the military used the building as a noncommissioned officers' club for Camp Lockett. Later, the San Diego Historical Society, the Native Sons and Daughters of the Golden West, and the California State Historical Association added their support to the rehabilitation project. On May 9, 1948, a bronze plaque denoting the Campo Stone Store's historic designation was unveiled with a special program. County Supervisor DeGraff Austin (below) was a featured speaker.

Two

Park Growth under First Director

As World War II came to a close, San Diego County civic and community leaders felt there was an immediate and postwar need for the establishment of an office of county recreation. In February 1946, a specialist was appointed to survey the recreational needs of the county. The ensuing report recommended appointing a recreation director and establishing a recreation commission. The county board of supervisors acted quickly and appointed Cletus "Biff" Gardner for temporary employment as director, beginning July 1, 1946. The supervisors wanted the position to be permanent, so the final decision was based on a civil-service examination. According to Gardner's oral history, he scored first in a group of about 40 applicants nationwide. The three highest scorers were interviewed, and the position for Gardner was made permanent in February 1947.

Gardner arrived to start work with no budget and no office. According to an interview, he "wandered up and down the halls [of the civic center] for a while" until he met someone from the Property Department, who let him sit at the desk of a vacationing secretary. When Gardner took over, the park inventory consisted of 22 parks, many of which were beach parks.

During Cletus Gardner's directorship, County of San Diego lifeguard service transferred from the sheriff's office to the Department of Recreation. Gardner was tasked with participating in a statewide historical marking program to honor the centennial of the Gold Rush and California statehood. By 1957, his department was retitled the Department of Parks and Recreation.

Between 1946 and Gardner's retirement in 1972, the park network expanded by cooperating with other agencies and by purchasing sites, outright, to serve the rapidly growing county population. This chapter highlights some of the parks that were secured or strengthened during Cletus Gardner's early tenure. Other parks from that era can be found in the chapters highlighting regional parks, preservation, and camping.

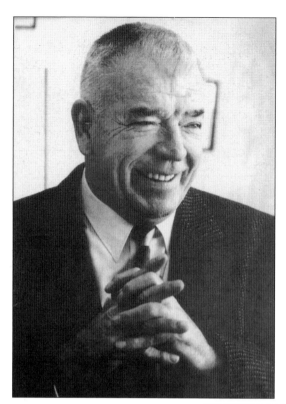

Photographed about the time of his retirement, Cletus Gardner served as first head of the department. A football star at Villanova University and a Sweetwater Union High School coach, he assumed his director duties shortly after serving in World War II. Gardner also had a 19-year career as a National Football League referee. Weekends would often find him officiating high-school, college, and professional games.

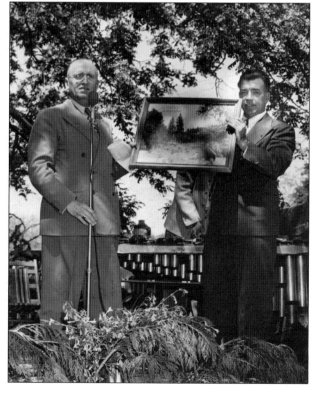

Performing one of his earliest duties, Gardner (far right) officiated as the secretary for the County of San Diego Historic Markers Committee. Here, he and Frank Forward, representing the San Diego Historical Society, participate in the 1948 program dedicating the site of Julian Pioneer County Park. Gardner was responsible for the wording on most of the plaques placed by the markers committee.

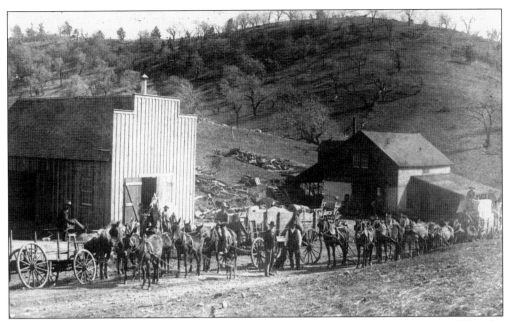

The gold-mining town of Julian had its start in 1870. In this photograph from about 1896, the blacksmith shop of Joseph Treshil is on the left, and on the right is the stone brewery operated for a time by Peter Mayerhoffer. The brewery building was leased from Treshil, having served as Treshil's first blacksmith shop. Mayerhoffer once advertised that the "Julian brewery is now making the finest beer in the United States." (Julian.)

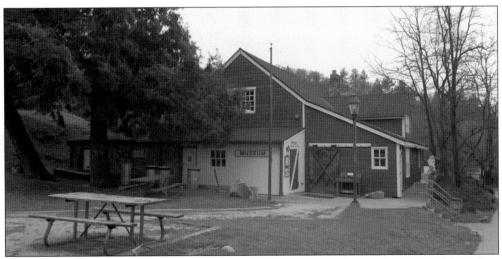

Seen in the present day, the restored stone brewery/blacksmith shop is the home of the Julian Pioneer Museum. Blacksmith Christian Grosskopf bought the site in 1897 from Joseph Treshil and his wife. Like Treshil and Mayerhoffer, Grosskopf was a naturalized citizen from Germany. Grosskopf married Annie Barber in 1905, and they owned the building until their deaths in the 1940s.

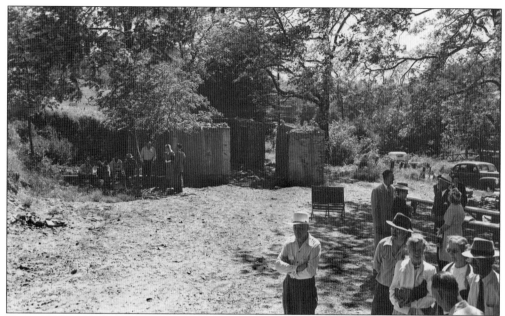

In 1945, a group of 35 Julian citizens filed a petition with the board of supervisors, asking them to purchase the former blacksmith-shop site for a park. The land was acquired the following year. A Julian pioneer picnic and historic marking was held on June 13, 1948 (see this page and pages 36 and 39). The deteriorated condition of the building's walls—two feet thick, made of schist and adobe—can be seen in the 1948 photograph.

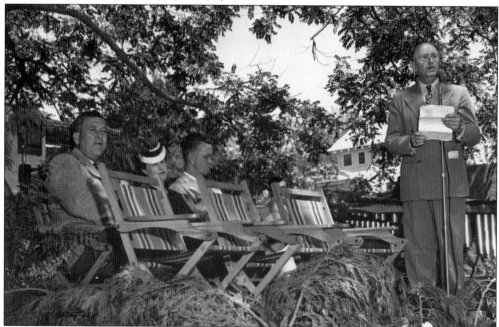

The historic markers committee organized the Julian site dedication. Participating here, from left to right, are Supervisor DeGraff Austin, Native Daughters of the Golden West president Frances Crawford, Supervisor Dean Howell, and Frank Forward of the San Diego Historical Society. Event attendees proposed plans for picnic tables honoring Julian pioneer families.

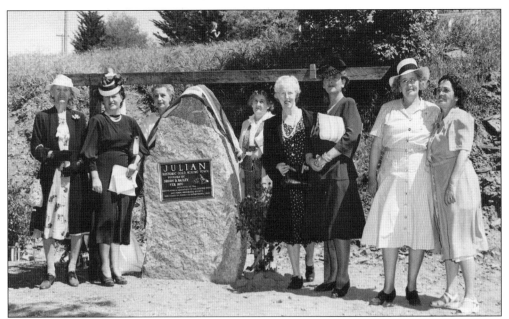

Members of the Julian Woman's Club and the Native Daughters of the Golden West pose in 1948 with the newly unveiled Julian plaque. The woman's club wanted the old blacksmith shop converted into a museum. Ida Bailey Wellington, daughter of the pioneering Drury D. Bailey family, stands at the far right.

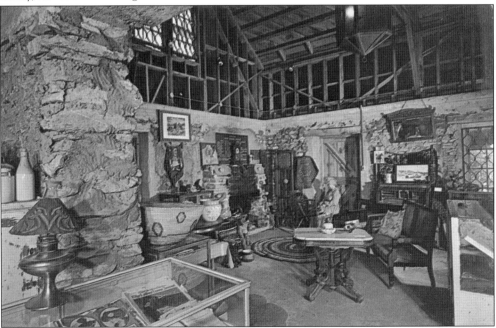

This postcard captures the interior and many collections of the Julian Pioneer Museum, a perennial project of the Julian Woman's Club. The collections were the dream of Alice Blanc, who gathered items for display. Volunteers worked on the restoration of the museum, which opened in 1952 with a barbecue for the Fourth of July and a dedication on the locally celebrated "Apple Day" in October.

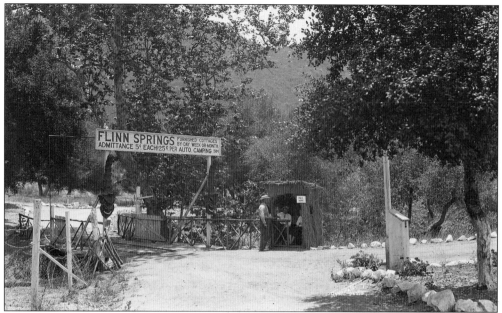

Flinn Springs County Park was once a privately owned resort with grounds that were quite popular in the 1910s, 1920s, and 1930s. In 1921, for instance, the Shriners took over the resort for their family picnic, which included a dance, pie- and watermelon-eating contests, an obstacle course, a nail-driving contest, and baseball and swimming competitions. The resort entrance was photographed about 1915. (SDHC.)

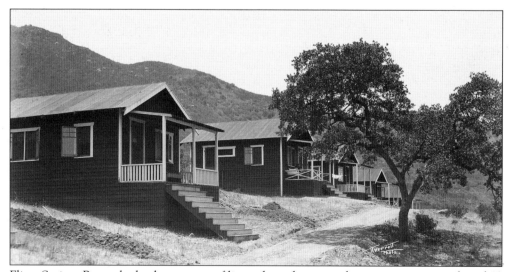

Flinn Springs Resort had a dense grove of live oaks, a dance pavilion, a swimming pool, and 10 wooden cabins. The dance pavilion was a concession with weekend dances, featuring 5¢ dances on Sunday afternoons. Advertised in the San Diego newspapers, the popular, orchestra-led dances drew people to the backcountry. (SDHC.)

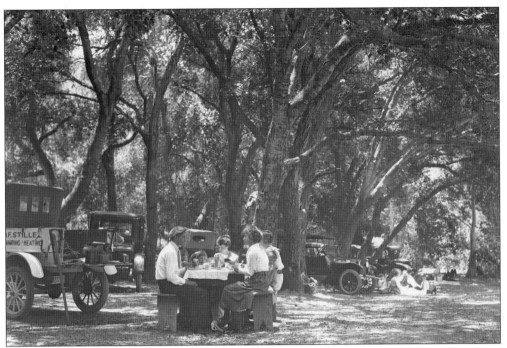

This part of Rancho El Cajon was home to the pioneering Ames and Flinn families. Picnicking at Flinn Springs has had a long tradition. According to Julia Flinn De Frate, the Fourth of July in 1876 was given a special observation here, with a large picnic for the neighborhood to celebrate the nation's centennial. Above, a different picnic takes place around 1915. (SDHC.)

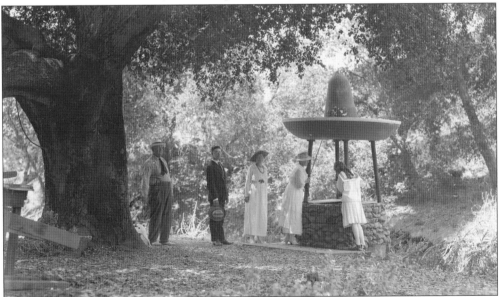

In this photograph, also taken about 1915, a well-dressed group gathers around a wishing well at Flinn Springs Resort. The park was procured from the resort operators in 1952. Today, the park is a popular venue for weddings and special events. The attractiveness of the area has kept visitors coming to enjoy the heritage oaks, the stream flowing through the park, and the mountainous backdrop. (SDHC.)

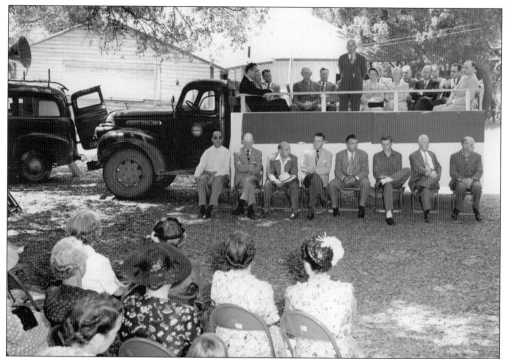

Flinn Springs County Park was dedicated in a program of music and entertainment on May 10, 1952. A US Navy band, glee clubs and choruses from local schools, and a Marine Corps color guard participated. Officials of El Cajon and La Mesa, representatives of the chambers of commerce of these communities, judges, supervisors, and members of the Flinn family were present. Julia Flinn De Frate, daughter of the former owner, James E. Flinn, related her family history. In the photograph above, John Davidson of the San Diego Historical Society is a key speaker. (Both, SDHC.)

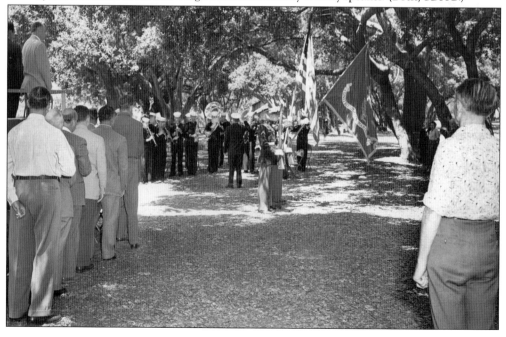

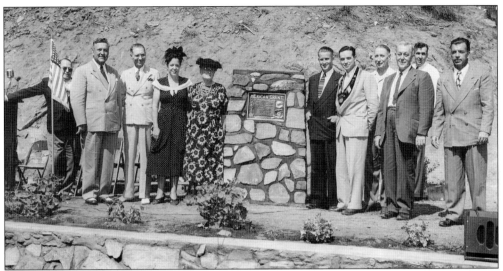

Cañada de Los Coches was the smallest of the Mexican land grant ranchos in San Diego, only 28 acres in size. Granted to Apolinaria Lorenzana by Gov. Manuel Micheltorena in 1843, it was once the grazing ground for hogs from the San Diego mission. Director Gardner (far right) and the historic markers committee dedicated a monument designed by the Native Sons of the Golden West on August 29, 1948.

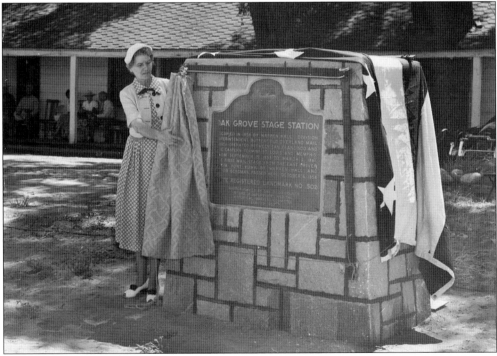

Three Butterfield Overland Mail stage stations remain in San Diego County. Oak Grove Stage Station, in the northern part of the county, was marked with a bronze plaque and monument erected by the County of San Diego Public Works Department on August 23, 1953. In this photograph, Margaret Conkling (whose husband, Roscoe Conkling, was a Butterfield historian) unveils the plaque. The stage first ran through here in 1858.

In 1926, Judge Lawrence Neil Turrentine and his wife, Carrie May, gave the County of San Diego 0.9 acres of forested land on Palomar Mountain. They added more land to the donation seven years later on the condition that the County of San Diego cancel outstanding taxes on the parcel. However, access to the facility was often a problem. The park was improved under Director Gardner in the 1950s and 1960s.

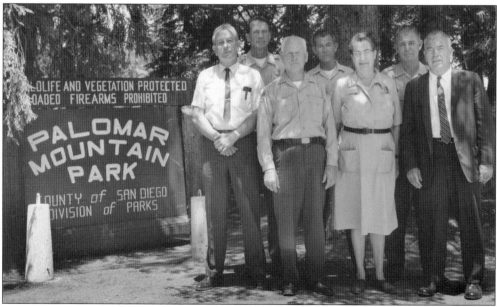

This photograph from 1967 memorializes the retirement of ranger Thelma Samside. She is surrounded by Director Gardner (far right) and other staff. Ralph Tillinghast, who died in 1948, served as an earlier Palomar park caretaker. At the park, a stone marker with a bronze plate honors his memory.

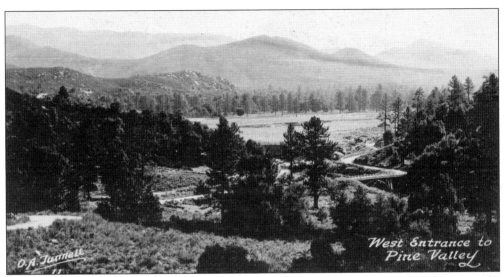

West Entrance to Pine Valley

O.A. Turnett

El Valle de los Pinos (Pine Valley) was the home of William Emery, who settled there in 1869. Emery, a former sea captain, bought up stage stations on the Colorado Desert between Yuma and San Diego and opened stores in them under the name Emery Brothers. With his large family, Captain Emery was able to keep his operation running until railroads ended stagecoach travel across the desert.

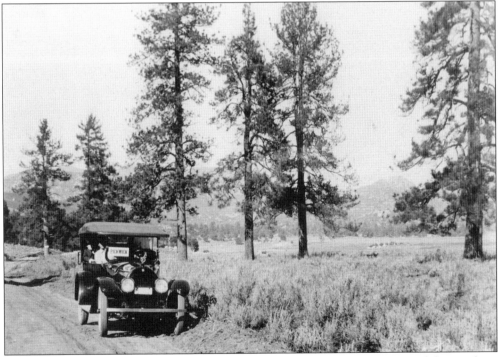

Auto stages such as this Pickwick one in Pine Valley replaced the earlier stagecoach lines, taking people from San Diego to Imperial County and into the backcountry on a daily basis in the 1920s and 1930s. The San Diego County Board of Supervisors accepted a deed for 17 acres from the Pine Valley Company in 1961. The resulting park remains an excellent place for travelers to stop or for locals to relax.

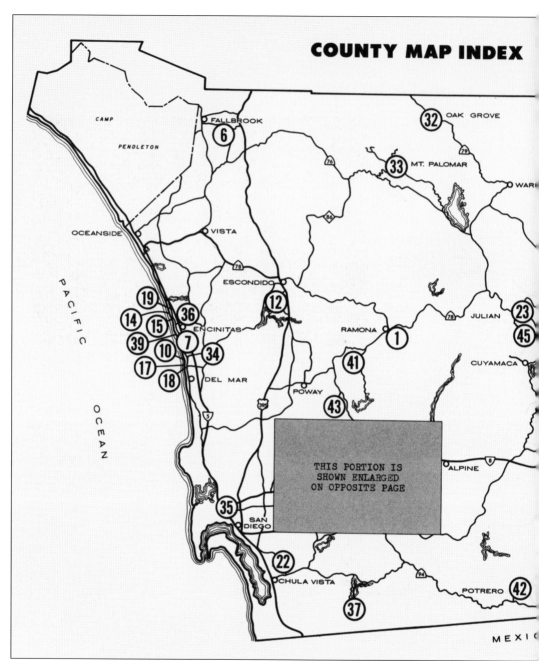

COUNTY MAP INDEX

A park inventory was published in July 1970. Parks listed are 1. Collier; 2. Goodland Acres; 3. Mountain Springs; 4. Lindo Lake; 5. El Monte; 6. Live Oak; 7. Glen; 8. Nancy Jane; 9. Cactus; 10. Tide; 11. Mount Helix; 12. Felicita; 13. Eucalyptus; 14. Encinitas Beach; 15. Seaside Gardens; 16. Vallecito; 17. Solana Beach; 18. Solana Beach Plaza; 19. Leucadia; 20. In-Ko-Pah; 21. Campo; 22. Lincoln Acres; 23. Julian; 24. Old Ironsides; 25. Los Coches; 26. Lemon Grove Center; 27.

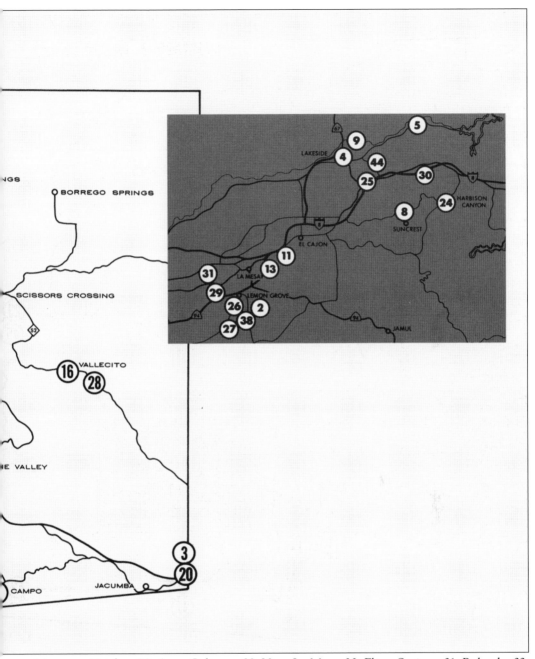

Monterey Heights; 28. Agua Caliente; 29. Vista La Mesa; 30. Flinn Springs; 31. Rolando; 32. Oak Grove Stage Station; 33. Palomar; 34. San Dieguito; 35. Whaley and Pendleton Houses; 36. Quail Botanical Gardens; 37. Lower Otay; 38. Lemon Grove; 39. Sea Cliff; 40. Pine Valley; 41. Dos Picos; 42. Potrero; 43. Sycamore; 44. Lake Jennings; and 45. William Heise.

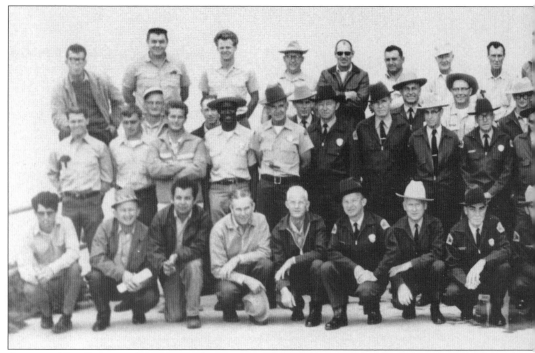

County of San Diego park rangers gather in 1967. The job classification of Park Warden I and II changed to Park Ranger I and II in 1961. A Park Ranger III position also began. Behind the

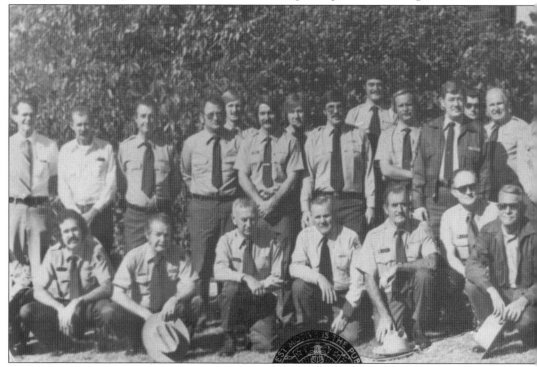

DPR's Provence House is the site for this 1976 photograph of parks and recreation staff. Lloyd Lowrey, who became the director in 1972, stands between two kneeling rangers. Lowrey had served

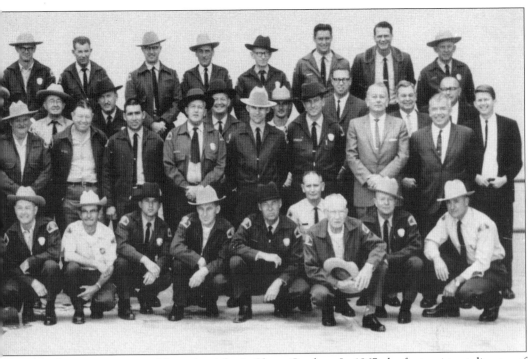

kneeling rangers, second from the right, is Cletus Gardner. In 1967, the first assistant director of parks and recreation, Ed Moses (on Gardner's left), was appointed.

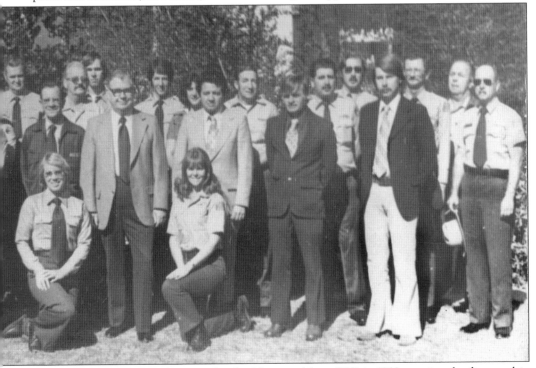

the City of San Diego as director of parks. He retired from DPR in 1982, turning the directorship over to Robert Copper. Copper is standing in the first row, second from the right.

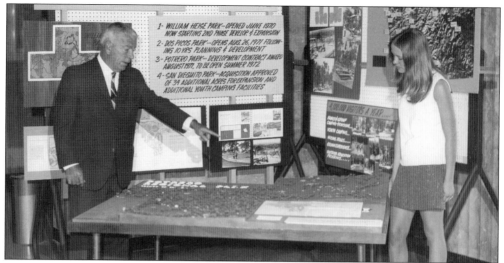

With a display at the County Administration Center, Cletus Gardner points out some recent park developments to a guest. Highlighted are William Heise Park, Dos Picos Park, Potrero Park, and San Dieguito Park. The 1970 inventory is visible in the background. Gardner retired with a dinner picnic at El Monte Park.

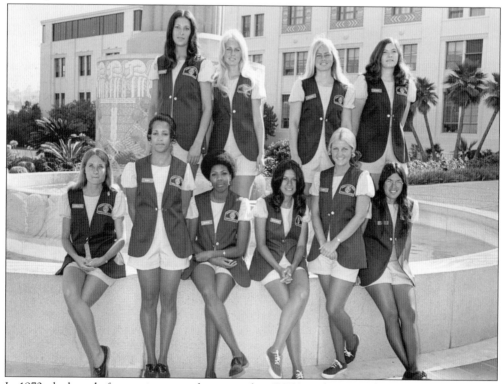

In 1972, the board of supervisors voted to streamline DPR's parks system by instituting electronic reservations, and to start a public relations program with "mini-skirted 'rangerettes.'" Posed here in front of the County Administration Center, the first group of rangerettes (also called ranger aides) included mainly college students. Some of these young women went on to careers as park rangers.

Three

BEACH PARKS AND
LIFEGUARD SERVICE

The County of San Diego started its lifeguard program in 1941. At that time, applicants took a combined city-county civil-service performance examination. Four men plus a captain were hired and provisioned with two dories and a used truck. Guards were stationed at Imperial Beach, Del Mar, Encinitas, and Carlsbad beaches.

William Rumsey, a former lifeguard lieutenant for the City of San Diego, became the first captain in the new county program. He was based near the Del Mar pier. During 1943–1944, the Army's combat-swimming and abandon-ship drills took place at Del Mar with county lifeguards watching over some 30,000 soldiers and nurses who jumped from the end of the pier to practice abandoning ship. During eight months of training, lifeguards performed 464 rescues.

On July 1, 1948, the lifeguard service transferred from the Sheriff's Department to the Recreation Department under Cletus Gardner. The following year, Gardner's annual report credited the lifeguards with 68 rescues and 763 first-aid cases with an estimated beach attendance of 373,425. Staff consisted of 5 permanent and 16 seasonal lifeguards.

County beach properties listed in the 1944 inventory are Solana Beach, Imperial Beach, Sea Cliff, Tide, South Coast Beach, Cardiff Beach, and Encinitas Beach. Many of these parcels were dedicated parks from land developers. For instance, Tide Park was a part of the Solana Beach Vista seaside community and was dedicated to public use in 1928. The South Coast Land Company deeded Seaside Gardens Park to the County of San Diego in 1930.

Lifeguard stations at Imperial and Solana Beaches functioned year-round, while the others were seasonal. As communities gradually started incorporating, they took over lifeguard functions in their areas. Carlsbad and Imperial Beach exited the County of San Diego system first. By 1970, the county department operated Solana Beach, Sea Cliff, Tide, Encinitas Beach, and some smaller beach-access locations. Today, DPR no longer operates beach parks or provides a lifeguard service.

The Ed Fletcher Company deeded Tide Park to the County of San Diego in 1928. The board of supervisors accepted it for a public park in 1948. Tide provided beach access via a steep stairway. Other small parcels monitored by the county for viewpoints or beach access included Seaside Gardens (Stone Steps), D Street (Boneyards), and J Street.

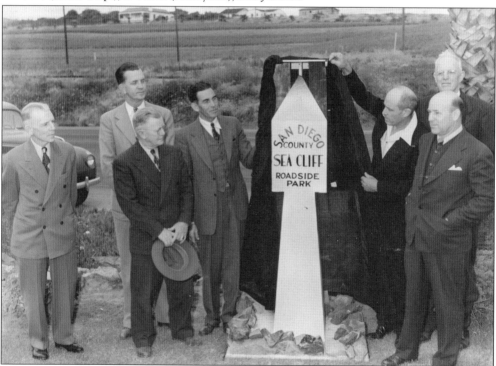

When Sea Cliff was dedicated in 1946, it was the first officially designated roadside park in California. Located south of Encinitas, the triangle of land and clifftop were deeded to the County of San Diego in 1914. Wooden steps led to the beach. Pictured with Supervisor Dean Howell (tall man, back left) are members of Encinitas and Cardiff civic organizations. The park is located next to the Self-Realization Fellowship Retreat.

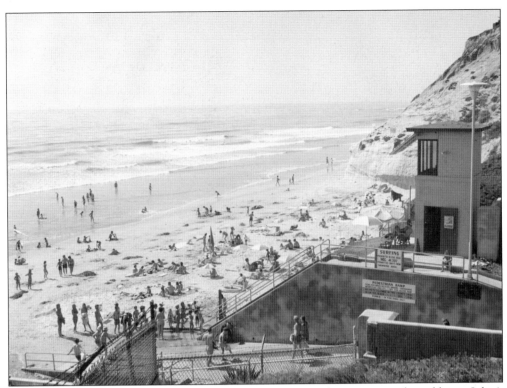

Community planner Ed Fletcher first opened his Solana Beach property to the public on July 4, 1924. The day's activities included horse racing on the beach. Fletcher deeded the beach park to the County of San Diego in 1931. During World War II, the Coast Guard requested use of the park and established a patrol unit.

Dedication of major improvements to Solana Beach County Park, featuring a beach-access ramp, took place in October 1969. Posing from left to right are Supervisor Robert Cozens, parks director Cletus Gardner, lifeguard captain James Lathers, and William Craven, administrative assistant to Cozens. The Solana Beach Lifeguard Station was headquarters for DPR's lifeguards. Presently, the City of Solana Beach lifeguard service is headquartered there.

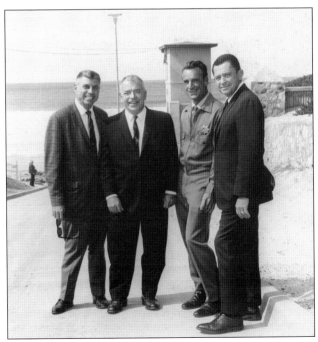

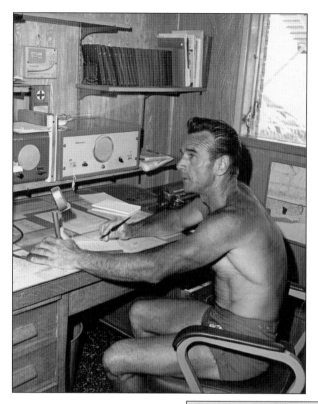

James Lathers served as the third lifeguard captain. He replaced Patrick Kahlow, one of the original lifeguards who started with William Rumsey. Lathers worked for DPR from 1947 to 1978, becoming captain in 1964. In this 1971 photograph, Lathers works at the Solana Beach headquarters. The books on the shelf above him are the yearly patrol logs.

DPR lifeguards form a pyramid in the mid-1970s, with Captain Lathers at the top. Per Lathers, "preventive lifeguarding" was the role of the group. They operated the only rescue boats between Oceanside and San Diego. As one of the first services to use a public-address system to warn swimmers, they led their field. Training with scuba gear and climbing equipment rounded out their preparation.

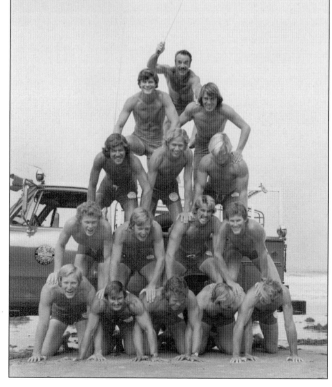

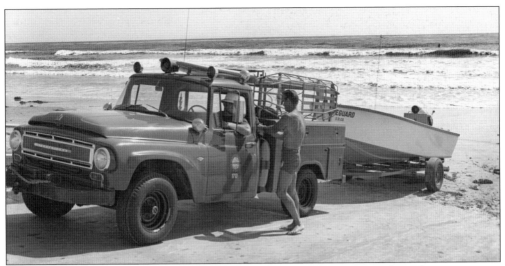

In the 1971 photograph above, tow chains, ropes, life preservers, first-aid supplies, respirators, surfboards, and basket litters equip the lifeguard emergency truck. Captain Lathers and Lt. Michael Considine (driving) are shown with the equipment. The lifeguard service had an outstanding record; Captain Lathers documented that in 30 years of service at guarded county beaches his staff performed 2,400 rescues with only one drowning. In the below photograph, taken around 1973, DPR lifeguards work on a rescued swimmer. Their International Harvester truck is put to its intended emergency use. Many of the other bathers seem unaware of the crisis and the professionalism displayed.

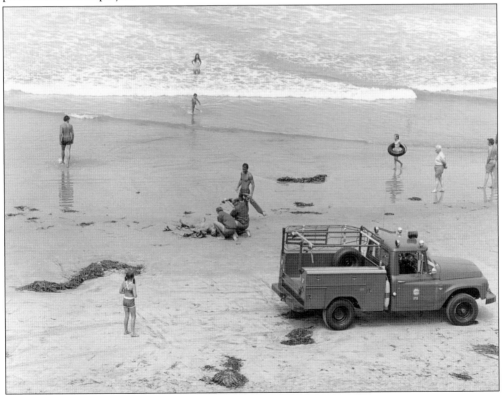

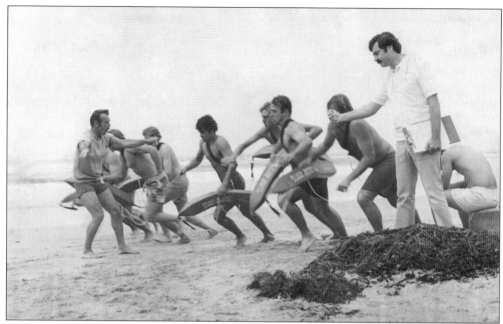

Captain Lathers supervises a performance-testing run and swim for lifeguards at Solana Beach in 1973. Another individual uses a stopwatch to time the event. Constant training reinforced the preventative lifeguarding program.

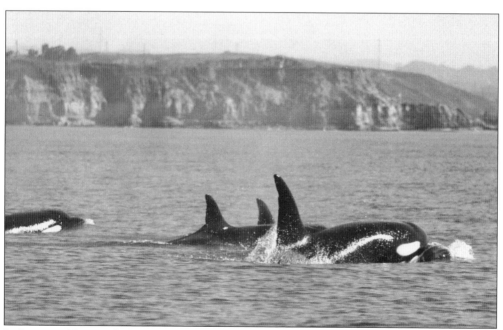

In January 1974, a pod of orcas, or killer whales, appeared off the coast of Solana Beach. County lifeguards Peter Zovanyi and Robert Schaer followed them in a skiff, herding them away from the beaches and south to La Jolla. In the process, the lifeguards cautioned two skin divers who were about to enter the water. From La Jolla, City of San Diego lifeguards took over and escorted the whales.

Four

Community Parks

San Diego citizens have long participated in their county park system by helping financially, sitting on committees, providing suggestions and guidance, and carrying out park operations when necessary. Teenagers in the Spring Valley Pals and Gals Club petitioned county supervisors for improvements to a community playground at Goodland Acres in the 1940s, collected $250, and helped with the installation. A nonprofit group, the San Diego County Parks Society, organized in 1980 to help with extra funding, park projects, and event planning—it continues to operate today. DPR could not function without community support.

A community (or local) park serves a small circle of people in a limited geographical area, generally within one to three miles of the park. The County of San Diego's local parks are usually not larger than five acres, and most of them are one-quarter acre to two acres in size. Several community parks feature community centers—some with associated sports complexes—that operate full programs of activities for all ages. DPR's parks in Spring Valley and Lakeside are among those with community centers, and Fallbrook and 4S Ranch are examples of locations with sports facilities.

In 1946 and 1947, the County of San Diego doled out over a thousand dollars in aid for community centers, specifying $250 to Fallbrook for the "establishment and maintenance of a community recreation center." The current Spring Valley Community Center has been open since 1981, and development on the Lakeside Community Center began the next year. Whether it was the junior rifle club in 1949, the bimonthly square dances of 1951, or the league sports played more recently, the offerings of DPR's community centers and sports parks have been meeting the needs of their immediate neighborhoods for decades.

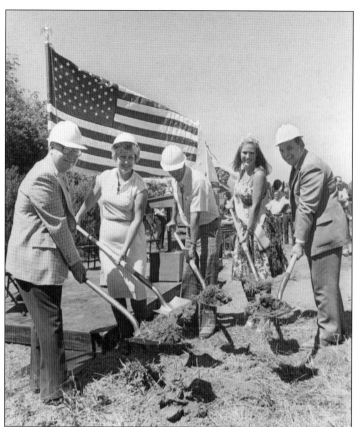

DPR director Lloyd Lowrey helped break ground for the Fallbrook Community Center and Park on June 12, 1980. From left to right, Lowrey is assisted by community volunteer Mary Bell, unidentified, Miss Fallbrook Deborah Parry, and County Supervisor Paul Eckert.

FALLBROOK COMMUNITY CENTER AND PARK
County of San Diego Fallbrook, California

The architectural firm of Ralph Bradshaw and Richard Bundy designed the Fallbrook Community Center in 1979. They planned the building to accommodate public gatherings as well as recreation, education, and social-service programs. Much of the planning and support for the community center came from citizen efforts.

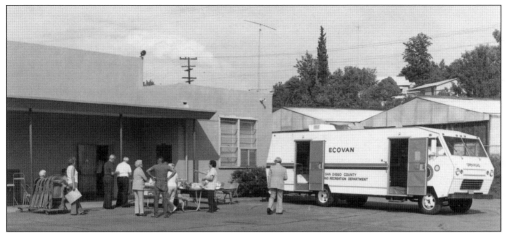

Spring Valley Community Center is in the La Presa area. David R. Goldman and Associates designed the building in the late 1970s. The main auditorium is named Ketell Hall in recognition of Herbert Ketell, the man credited with pushing the community-center project to completion. This photograph was taken during a resource fair where the Ecovan was present.

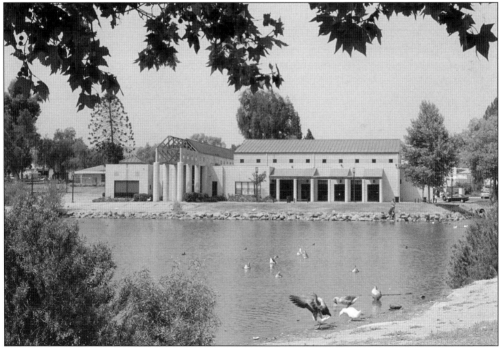

Lakeside Community Center is situated at Lindo Lake County Park. Using the Fallbrook Community Center as a prototype, this center opened in 1990 and was run by the Lakeside Community Services Association. DPR took over its operation in 1997. In 2002, the center's Meyer Hall was dedicated in honor of Lakeside activists and community-center volunteers Albert and Dolores Meyer, who put in more than 20 years of service.

DPR manages six parks, including a sports complex, in the 4S Ranch community. This area was originally part of Rancho Bernardo, the Mexican land grant given to Capt. Joseph Snook and his wife, María Antonia Alvarado. Sheriff James McCoy secured the land from their heirs. In 1909, the Eucalyptus Culture Company of San Francisco purchased 4,000 acres to start planting eucalyptus trees for commercial purposes.

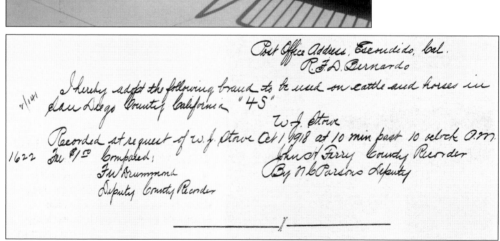

The official San Diego County brand-book entry dated October 1, 1918, for the registration of the 4S livestock brand is recorded in the name of W.J. Stowe. The William James Stowe family came from Los Angeles; the Eucalyptus Culture Company sold land to Ada Stowe in July 1918. In addition to William and Ada Stowe, the family counted two sons—hence, the "four S" brand and subsequent community name.

Albert Edward Smith, depicted in a 1918 *Motion Picture News* portrait, also owned 4S Ranch. Smith was president and cofounder of Vitagraph Studios, a pioneer in the silent film industry. Smith and his wife, actress Jean Paige, put out orange trees, sunk wells, built a dam, and planned a large mansion after taking ownership of the ranch in 1921.

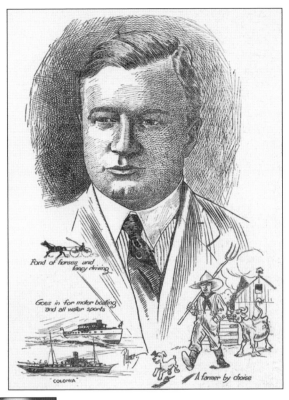

This portrait captures a smiling Mabel Walker Willebrant, US assistant attorney general from 1921 to 1929. In a complicated legal arrangement, she traded Hollywood's Chateau Marmont to A.E. Smith in exchange for 4S Ranch in 1931. With a contract from the county board of supervisors and Mabel Willebrant, the Workers' Benevolent and Protective Association put the unemployed to work on 4S cutting eucalyptus wood.

The 4S Ranch was most recently owned by Ava Ralphs and Albert Ralphs, son of the founder of Ralphs Grocery Company. They are pictured in the photograph (center) with their son Richard (far right) shortly after they acquired 4S in 1938. Family member Felix Chappellet is at the left. The Ralphs family used the ranch as a retreat and did little to modernize the facilities, preferring the lifestyle of a simpler time. (LRK.)

Ava Ralphs stands overlooking Lake Hodges. The lake forms the northern border of the ranch, a section still owned by the Ralphs family. Eventually, the family decided to develop the southern part of the ranch in a way that preserved its openness and family-friendly atmosphere. They still participate in decision-making for this first master-planned community outside the city of San Diego. (LRK.)

Five

REGIONAL PARKS

A regional park serves a large geographical area with both passive and active recreational opportunities. Passive recreational activities, such as hiking and observing wildlife, are self-generated and can occur in minimally developed, environmentally sensitive areas. Active recreation—playing sports, for example—requires significant infrastructure for organized activities or events. Because this demands considerable space, regional parks are often large—200 acres is an approximate minimum size. DPR has offered the diverse recreation and higher acreage that are necessary to meet different regions' recreational needs for decades. In 2016, the County of San Diego parks system contained 19 regional parks; this chapter highlights the histories of five of them.

Felicita County Park, San Dieguito County Park, Otay Lakes County Park, Otay Valley Regional Park, and Tijuana River Valley Regional Park hold among them land that is both beatific and popular. On the Escondido locality that would become Felicita, an 1892 newspaper conjectured, "It is capable of being made an earthly paradise." A budget statement from 1988 noted that San Dieguito was "the busiest and highest-revenue-producing picnic park in the County [system]" and one that had its reservable areas fully booked a year in advance. At a deed-transfer ceremony for Otay Lakes, a speaker emphasized the intent to differentiate it "from the typical urban community park" by making it "a place that people can escape to." Otay itself was described as a wonderland where "the ocean's raw winds are melted into delightful zephyrs." Finally, Tijuana River Valley, just north of the Mexican border, was recognized as "one of the most important birding areas in the United States." Though many of DPR's regional parks are also classified as camping parks or historic sites because classifications frequently overlap, they are alike in their attractiveness to large sectors of San Diego County residents.

The County of San Diego obtained property for Felicita County Park in 1929 at the urging of the Escondido Chamber of Commerce—Escondido was the only community in the county without a public park. Landowner Ransford Lewis sold the property for $12,000 with the agreement that he would remain for one year as its caretaker. In the photograph above, Lewis and his family camp on park land.

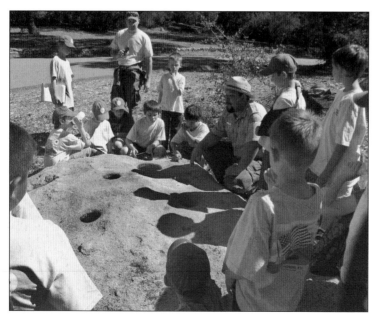

Long before the Lewises lived there, and before they were pushed out by lawmen and settlers, Kumeyaays inhabited the land. The grinding holes where village women ground acorns into flour are still evident in Felicita's bedrock. In 2008, the Felicita County Park Prehistoric Village, representing a village site between 150 and 1,800 years old, was placed in the National Register of Historic Places.

Felicita, for whom the park was named, was the daughter of Panto, *capitán* of the San Pasqual Band of Diegueño Mission Indians. Though their traditional home was never actually in Felicita parkland, it was close by. When Felicita died in 1916, she had seen California history during the Spanish mission era, the Mexican period, and US statehood.

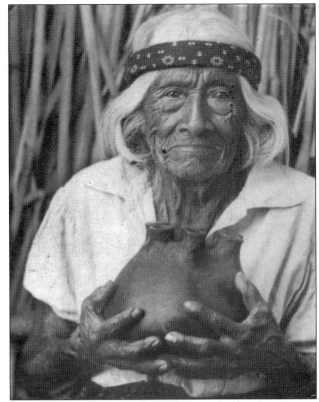

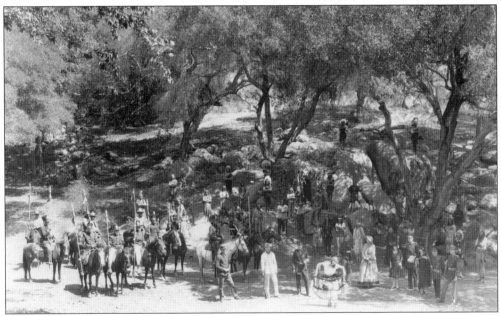

A highly fictionalized pageant of Felicita's life was presented from 1927 to 1931 and again in the 1970s, 1980s, and early 2000s. It was written by local optometrist Benjamin Sherman, who based his account on the book *Indian Stories of the Southwest* by Elizabeth Judson Roberts. Roberts, despite knowing Felicita personally, told her story as a mixture of truth and fantasy.

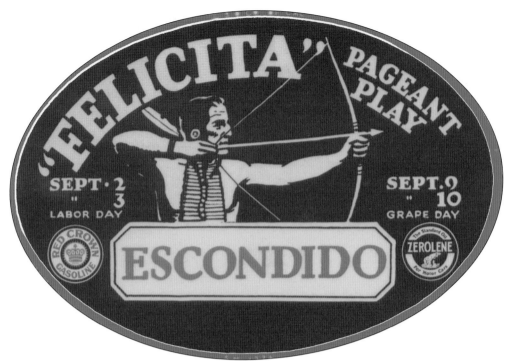

Radiator emblems such as this one for the 1928 production, handed out by gas stations, attracted spectators to the amphitheater where the pageant was held. Though the amphitheater itself was not within the boundaries of Felicita Park, motorists did use parkland as a parking area. At least one of the modern resurrections of the pageant appears to have been staged inside the park.

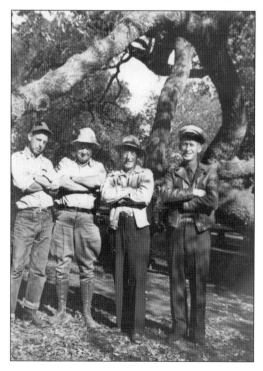

James Earl Shidner served as Felicita Park's caretaker from the early 1930s to about 1950. Shidner (far right), pictured with (left to right) Lee Roseberry, William Beven, and George Miller, used County of San Diego–owned mules to haul materials until 1941 when the park was issued a motorized vehicle—a Model T truck.

Surrounding Felicita's band shell—shown here in 1941—are groves of live oak trees. Once called "torture trees" due to their twisted appearance, legend told that Indians used them to punish villainous individuals. After binding victims to the trees, tree surgeons supposedly grafted branches around them so that they would be trapped in "ever-pressing bonds of living oak." This sensationalistic story, even featured in Ripley's syndicated newspaper column "Believe It or Not," was completely fabricated.

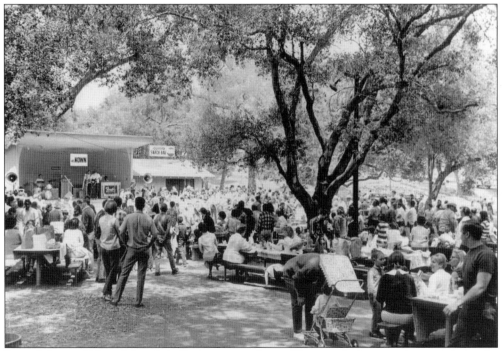

Remodels cost Felicita's band shell its acoustic dome. The attached concession stand, run for many years by Earl Shidner's wife, Nora, served generations of park visitors—as well as, in the 1940s, US Marines from Camp Pendleton. The men, conducting training hikes, filled the park with military vehicles and pup tents. Their stays were very profitable for Nora, who did a hearty business selling Bowie Pie Company pies for a nickel apiece.

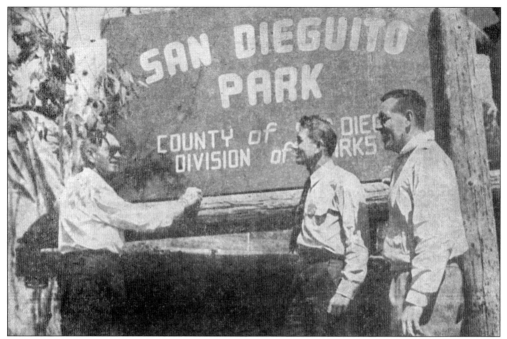

The San Dieguito Junior Chamber of Commerce (JCC) worked with DPR and the Santa Fe Irrigation District to sponsor San Dieguito County Park. The district granted land; the JCC "purchased" it for $10. Deed restrictions, such as the requirement that park buildings pass muster with the local architectural committee, tied things up for years, and by the time the JCC presented its huge, hand-drawn check, it bounced. (*San Dieguito Citizen*.)

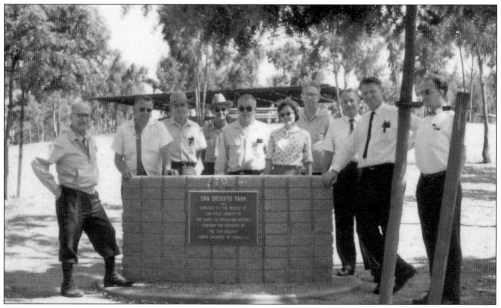

San Dieguito Park was dedicated in December 1956, with the participation of Boy Scouts, the San Dieguito Union High School band, and a choral group from Earl Warren Junior High. Almost nine years later, a bronze plaque was unveiled to recognize the efforts to acquire approximately 100 acres of land for the park.

San Dieguito's land was once owned by the Santa Fe Land Improvement Company, a subsidiary of the Santa Fe Railway. The company planted thousands of eucalyptus trees on the property, hoping to use the wood for railroad ties. The trees, however, produced unusable timber—once it was logged and made into railroad ties, the eucalyptus warped. Extensive eucalyptus groves, remnants of this costly experiment, still shade parkgoers.

Landscape engineer Ralph Noyes prepared a master plan for San Dieguito; elements composed of logs so enormous that they required helicopters to lower them into place were thoughtfully formulated. Noyes's visions proved artful, for the *San Diego Union* declared in 1984 that "if there were a beauty contest for parks, San Dieguito . . . would win."

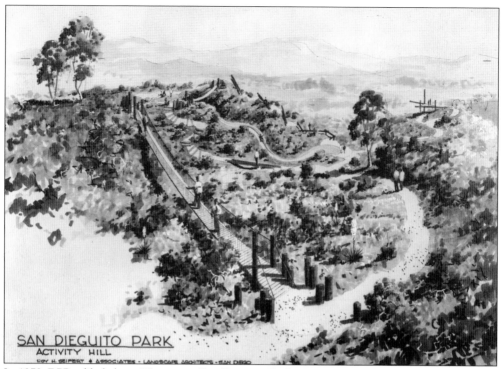

SAN DIEGUITO PARK
ACTIVITY HILL
ROY H. SEIFERT & ASSOCIATES - LANDSCAPE ARCHITECTS - SAN DIEGO

In 1973, DPR added about 25 acres to San Dieguito Park. Activity Hill, built on the new land in 1974, featured lookouts and bridges "providing a native African effect." The centerpiece of Activity Hill was a "superslide" that was about 100 feet long. It was designed by San Diego architect Roy Seifert and delivered a thrill ride that lasted around 10 seconds.

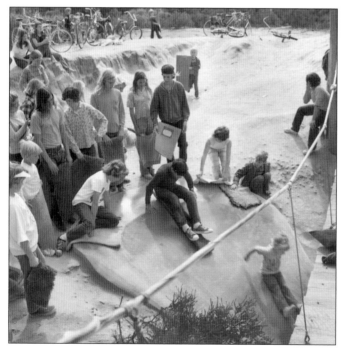

People misused the slide, designed like a toboggan run with banked sides on curves, from the start. Riders shot down it by spraying wax on carpet squares, towels, cardboard boxes, and more. Park rangers also witnessed people using skateboards and motorized vehicles. A child even rolled down the slide in a trash can.

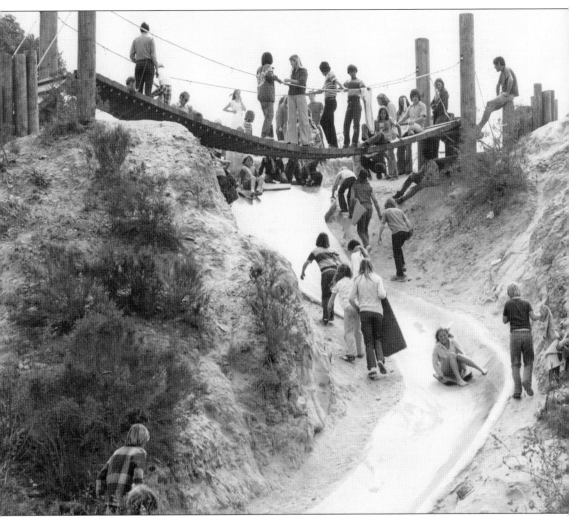

Injuries were rampant. In 1974, a 12-year-old hit his head, lost his memory, and thought it was "still Easter Sunday" (celebrated three days before). Unsurprisingly, the slide's dangerous qualities did not hinder its popularity; the *San Diego Union* wrote in 1975 that "there is other playground equipment in the park, but the superslide gets all the real action." DPR attempted modifications, including railings "to prevent children from flying off the sides," but the slide became so notorious among area doctors that the department closed it in 1975. The whole affair caught architect Seifert by surprise. "The slide was designed as a spiritual lift as you move through the landscape of the park," he claimed. "I didn't dream kids would be doing what they are doing on it."

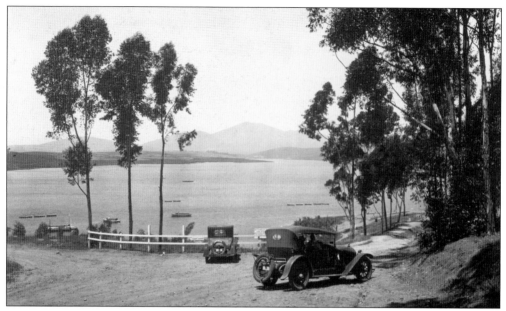

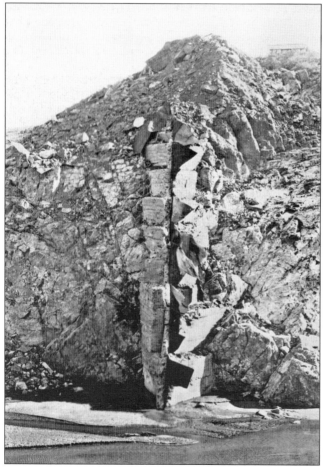

Also historically popular, Lower Otay Lake is depicted here in 1926. The parkland around the lake came under DPR control when the County of San Diego started leasing it in 1957. It closed in 1991 when it needed expensive repairs, but in 1997, the California Department of Transportation bought the land as a mitigation measure and gave it to DPR to be operated as Otay Lakes County Park. (SDHC.)

The dam that created Lower Otay Lake burst on January 27 in the notable flood of 1916. The dam discharged approximately 13 billion gallons of water in only 150 minutes and, as this photograph illustrates, the only vestiges of its existence were boiler plates protruding from cement abutments. Elisha S. Babcock and John D. Spreckels built the dam in 1897 to collect water for Babcock's Hotel del Coronado. (SDHC.)

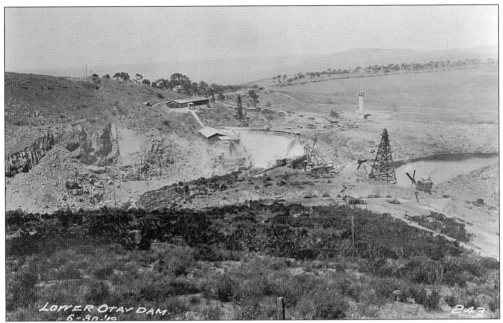

Spreckels sold the dam in 1913 to the City of San Diego. The Lower Otay Reservoir and Otay Water Treatment Plant were important sources of the city's drinking water, so after the flood, the dam was promptly rebuilt under the direction of city hydraulic engineer Hiram Savage. The new dam, officially known today as Savage Dam, was completed in 1919. (SDPL.)

Building the new Otay dam was such a prodigious task that a virtual town for the hundreds of workers—three-quarters of them Mexican—was erected near the site. Higher wages offered elsewhere kept costing the dam its laborers, so theater troupes such as the Wright-Power Dramatic Company were brought in to boost morale. Pictured from left to right are unidentified, William Hardcastle Wright, Sybil Stone, Nanette Kallim, and Patia Power. (SDPL.)

The City of San Diego provided a vaudeville show and a moving picture show every week, plus the use of a player piano and "athletic and entertainment appliances" after labor turnover amounted to 164 percent in a single month. At one point, Lower Otay retained only 15 workers. Not until February 1919 did it became possible to employ enough people for construction work to advance economically. (SDPL.)

Otay managers capitalized on the many individuals in San Diego who took the stage for World War I troops, persuading these "war work circuit entertainers" to divert to the dam site. For nearly a year, YMCA performers, such as this singing group in 1919, contributed entertainment valued at over $150 to the workers' town each month. (SDPL.)

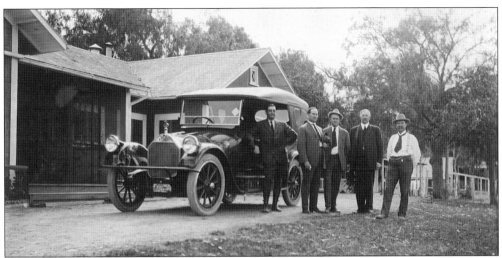

The dam workers' town centered on the land that became Otay Lakes County Park, and its base camp was an adobe dwelling E.S. Babcock built as a quail-hunting lodge. In this 1918 photograph, (from left) Los Angeles banker Irving H. Hellman, John C. Cooper, Sollie Aronson, an unidentified hydraulic engineer, and contractor James Kennedy pose in front of the former lodge. (SDPL).

This building, pictured in 2016, is Babcock's lodge from the previous photograph. Otay Lakes Park uses it as a ranger residence. Babcock had the adobe ranch house constructed in 1895 for approximately $1,200. Historian W.E. Smythe wrote of Babcock, "[He] came to San Diego in 1884 to hunt quail and remained to influence events more powerfully than anyone since [Alonzo] Horton." Chiefly, Babcock "engaged assiduously in water development."

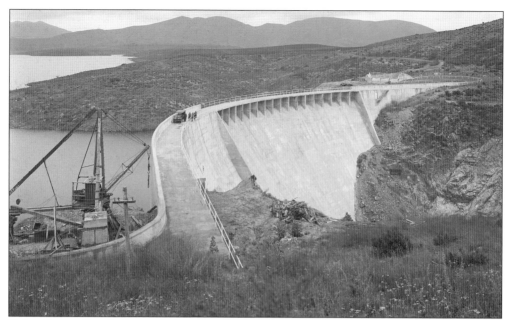

Today, Savage Dam looks much the same as it did in this 1920 photograph. Its crest is wide enough for automobiles to traverse, a fact several motorists took advantage of at the dam's dedication. The dam was christened with a smashed bottle of Otay River water. Hundreds of celebrants climbed down and up the steps that framed the dam's inspection tunnel—one woman fainted. (SDHC.)

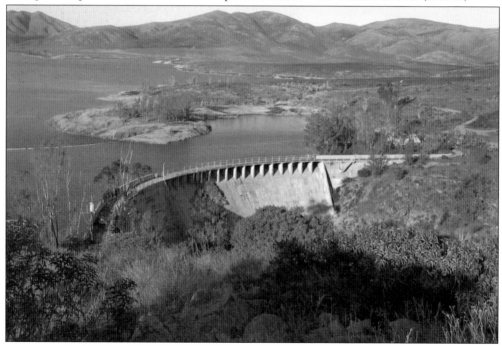

Hiram Savage designed a concrete arched dam, far stronger than the previous dirt-and-stone dam that was destroyed, which included some remains of the base of the original dam in its foundation. Constructing the 182-foot-high dam cost the City of San Diego $715,157.07. The dam and reservoir demarcate one end of the Otay Valley.

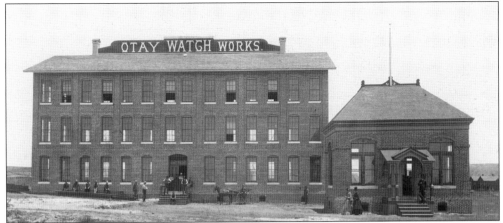

Otay Lakes County Park is the eastern gateway to Otay Valley Regional Park, proposed in 1989 as a 13-mile stretch from Lower Otay Lake to the coast. When the 1916 flood charged through Otay Valley, one of the few surviving structures was the Otay Watch Works, pictured around 1890. Built in 1889, the watch factory was supposed to invigorate the valley. (SDHC.)

The factory was located just north of the land that is now Otay Valley Park. The first watchmaking factory west of the Mississippi, it was hailed as "the core of a new Western industrial empire." Slow sales and high expenses, however, forced the factory to close after being in business for only 247 days. The building stood empty for years before it was demolished in 1934. (*Golden Era.*)

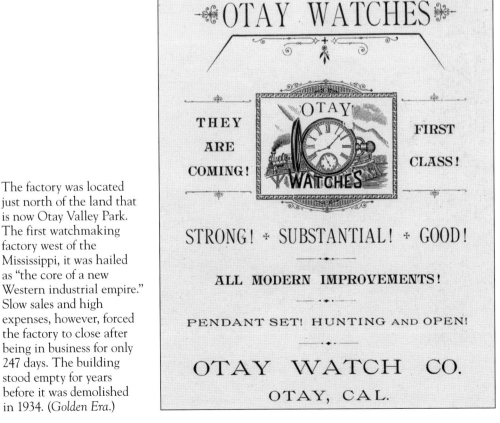

LOOK · OUT · FOR

OTAY WATCHES

THEY ARE COMING!

FIRST CLASS!

STRONG! ✳ SUBSTANTIAL! ✳ GOOD!

ALL MODERN IMPROVEMENTS!

PENDANT SET! HUNTING AND OPEN!

OTAY WATCH CO.
OTAY, CAL.

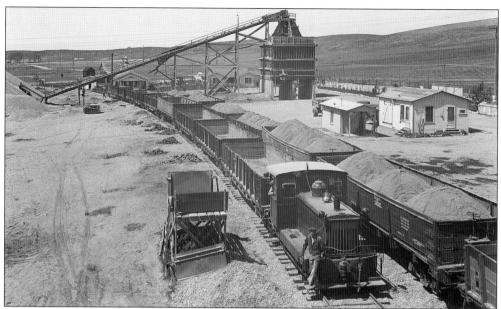

Commercial mining in Otay Valley began in 1912, when Henry Fenton hauled sand and rock for Babcock's Coronado Beach Company. Another operation, Spreckels Commercial Company (above), excavated near the eastern end of Otay Valley Park. Some of the land that composes the park came from in-trades with the H.G. Fenton Material Company. Ponds, which are prime birding spots today, are remnants of the mining. (SDHC.)

Otay School, north of the midpoint of Otay Valley Park, opened in 1889. Pupils in grades one through eight attended classes in this building—a photograph captures them standing before it in 1917—which remained in use until 1924. A series of new school buildings followed. John. J. Montgomery Elementary School operates on the site today. (SDHC.)

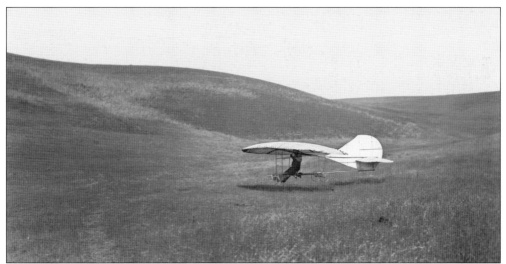

John J. Montgomery, an engineer and scientist, made history in 1883 when he purportedly was the first person in the United States to be supported freely in the air in a heavier-than-air craft without power. Montgomery reportedly flew a fixed-wing glider 600 feet from a hilltop on the edge of Otay Valley Park, the then-location of his father's farm. (SDHC.)

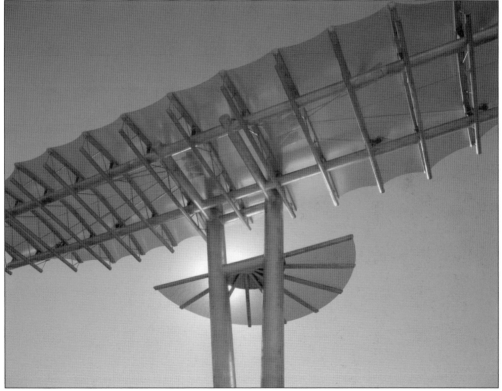

DPR and the Cities of Chula Vista and San Diego collaborated on an overlook celebrating Montgomery. It features designs inspired by his exploits: shade structures in the form of airplane wings, a circular patio resembling a propeller hub, and seats shaped as nuts and bolts. Dedicated in 2005, the multi-jurisdictional outlook sits in the similarly multi-jurisdictional Otay Valley Park.

The Thomas Louis Shelton Sr. family came to the Tijuana River Valley in 1947, where they engaged in farming and dairying on land that became Tijuana River Valley Regional Park. The property contained a small house, built in 1912 or 1913, which had just been relocated from another valley ranch. This 1950 photograph shows Willard Layton, Shelton's son-in-law, and his daughters Pam and Ann in front of the dwelling. (DS.)

Eventually, the Laytons moved to Chula Vista and dairy workers lived in the little house. Then, in 1961, Thomas Louis Shelton Jr., his wife Donna, and their three small children took up residence. Daughters (from left to right) Robin and Nancy—with their sister Sara—are photographed on their first day of school in 1962. In 1984, Robin returned to live in the little home, staying there until 1989. (DS.)

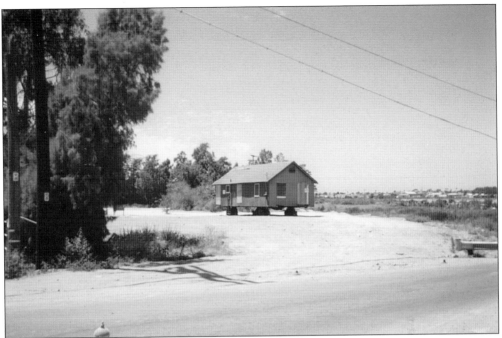

In 1988, voters approved California Proposition 70, providing money for land acquisitions in Tijuana River Valley. DPR purchased the Shelton property. After debating the use of a converted "small ocean-cargo container" for a park visitor center, the department decided to use the little house instead. In 1994, DPR spent $3,600 to move the house to a satellite site of the park. (DS.)

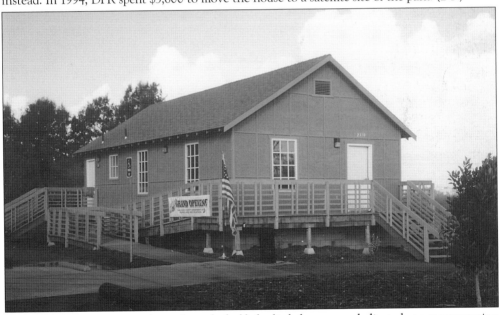

After traveling approximately a mile and a half, the little house was dedicated as a ranger station and visitor-contact center in 1998. Then, in 2002, it became the visitor center for the Audubon Society–advised Bird and Butterfly Garden planted around it. More than 350 species of birds have been recorded in the Tijuana River Valley—more than two-thirds of the birds that occur in San Diego County.

After outgrowing the little house, the Shelton family built a bigger ranch house up the hill in 1969. Then the farming business dried up, and the Sheltons sold their property. In 2000, DPR was granted the deed to the newer house, and by September 2003, park staff—who also outgrew the little house—upgraded to the bigger building and made it their Tijuana River Valley ranger headquarters. (DS.)

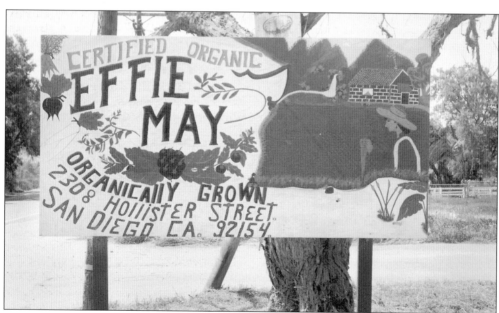

Tijuana River Valley Park holds one of DPR's four community gardens; the river-valley park's garden opened in 2002. Its site was a natural one, for it was previously the home of Effie May Organic Farms—specifically, the farm's vegetable stand. After DPR assumed stewardship of the land, park rangers had to frequently patrol the area to deter children who thought the abandoned stand made a splendid clubhouse.

Six

CAMPING PARKS

Whether they prefer a tent, an RV, or a cabin, campers can be accommodated at one of the (at the time of this writing) 706 campsites found in DPR properties such as Agua Caliente County Park, William Heise County Park, Guajome Regional Park, Lake Morena County Park, Dos Picos County Park, Potrero County Park, Vallecito County Park, and Sweetwater Summit Regional Park. Different DPR camping parks cater to different groups of people. Dos Picos is one of the parks with designated space for youth camping groups. Potrero has spaces for single-family camping and caravan areas for group camping. Vallecito and Sweetwater Summit welcome equestrian campers with campsites that include corrals.

Sweetwater Summit covers much of the open space left along the Sweetwater River. DPR purchased the park's first six acres in 1974 and, after debate over whether or not to build a golf course, dedicated them in 1992. Tipais, whose traditional territory encompassed Sweetwater, originally inhabited the area.

Lake Morena was also first inhabited by Tipais. Their cave campsites in the area are believed to be over 12,000 years old. The City of San Diego owns the lake and the surrounding land; it offered operation of both to the County of San Diego in 1963 because Morena's distance—about 40 miles—from downtown San Diego did not serve city residents very well. Hikers flock to Lake Morena Park because the Pacific Crest Trail passes through it.

Agua Caliente, William Heise, and Guajome Regional draw recreation-seekers as well. Agua Caliente was nicknamed San Diego's "Little Yellowstone" back in 1934. Seismic activity separated rocks and allowed hot springs to surface approximately 100 miles east of San Diego. This attracted Kumeyaays and, later, pioneers and prospectors. *Sunset* magazine named William Heise as one of the top campgrounds in the western United States. Guajome Regional, east of Oceanside, was originally the home of the indigenous Luiseños; the name *Guajome* comes from a Luiseño word meaning "place of the frogs." The park contains one of the largest freshwater marshes in the county, formed by runoff and the floodwaters of the San Luis Rey River.

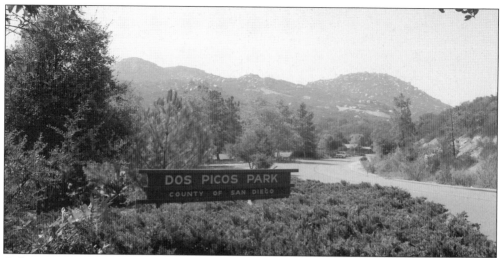

Oak trees—some roughly 300 years old—and mountains characterize Dos Picos County Park, a place Cletus Gardner called "the last pearl in a chain of the county park system." The indigenous Ipais first lived here thousands of years ago, and their grinding holes remain near the park's pond. Their land was seized by Spanish, Mexican, and American settlers, but hundreds of Ipai descendants still make the area their home.

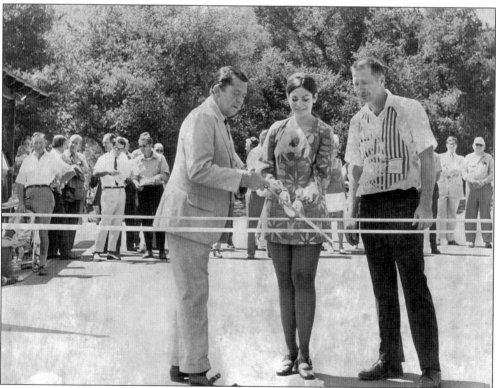

Dos Picos opened for public use on August 26, 1971. Helen Hudnal, runner-up in the Miss Ramona contest, cut the ribbon with help from County Supervisor William Craven (left) and Ramona Chamber of Commerce president Oscar Pike (right). The county public works administrator called the park a "little jewel" and noted, "It is probably our best one yet, with something for everyone."

In 1962, DPR acquired Dos Picos's 78.75 acres of land from Glenn and Dorothy Pearson for $50,074. The park was almost called Te-P-I Comu (pronounced Tea-Pea-I-Co-Moo); individuals from the Junipero Serra Museum, the Museum of Man, and the Scripps Institution proposed the name—purportedly meaning "Indian mortar holes"—that same year. Cletus Gardner joked about the barbs he heard for the proposed name: "People kept adding 'and Tyler too,' so it came out like the old political slogan." On March 5, 1964, "Dos Picos" was officially chosen instead. The name translates to "two peaks." Close to the park are two mountains that Gardner claimed differed in elevation by less than a foot. It is unclear which peaks inspired the name, although Iron Mountain was most likely one of them.

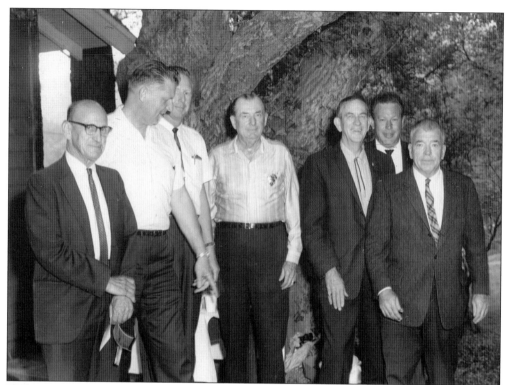

William Heise County Park received its name from the man (center) who sold 134 acres of land to DPR for $67,500—well below its appraised value—so it could become a park. Heise and his wife, Evelyn, finalized the sale on June 29, 1967. This photograph captures Heise on May 24, 1967, celebrating the soon-to-be-completed sale and wearing an honorary ranger badge he was given.

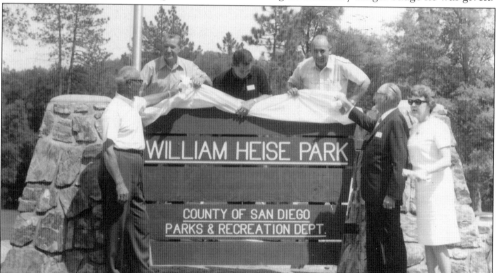

William and Evelyn Heise (right) help unveil the park sign bearing his name in 1970. Years before, William worked at a funeral home. Noticing pallbearers struggling with heavy caskets, he invented a side-loading hearse with a self-leveling table, which would lift a casket at the push of a button. Eventually, 90 percent of the hearses in California used the Heise Table.

Heise bought the Julian property for health reasons in 1941—he had ulcers and believed he would die. He lived, and when the park opened, a newspaper wrote, "A piece of land so beautiful it helped make a sick man well has been turned into a park." Cletus Gardner added—and these 1975 sledders can attest—that Heise Park "represents one end of the climatic spectrum we are fortunate to have."

The park grew by bits and pieces during the 1970s, 1980s, and 2000s, with one expansion being a parcel sold by the Woolman family. In the 1980s, approximately 95 percent of the land where generations of Woolmans had camped, picnicked, swam, and fished since the late 1920s was surrounded by Heise Park, so the family worked closely with the Parks Society to sell it to DPR. (WW.)

Unlike Heise, Agua Caliente, approximately 100 miles east of San Diego in the Colorado Desert, never sees snow. Agua Caliente was mistakenly homesteaded to Samuel Talmadge Losee (the law barred the government from homesteading desert springs). He was listed in newspapers in 1932 as Agua Caliente's caretaker. Losee built a two-room shack that probably looked much like this other Agua Caliente residence from around the same time.

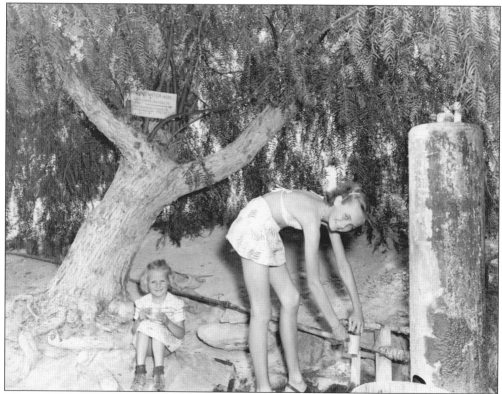

After Losee died, James K. and Blanche McCall (and their dog Jerry) managed Agua Caliente, building camp stoves and maintaining the pipeline from the spring to the campground. Campers generally came from the Los Angeles, Riverside, and San Diego areas to spend three or four months at the desert community. At any one time in 1947, Agua Caliente averaged 20 visitors—10 years later, that number had quintupled.

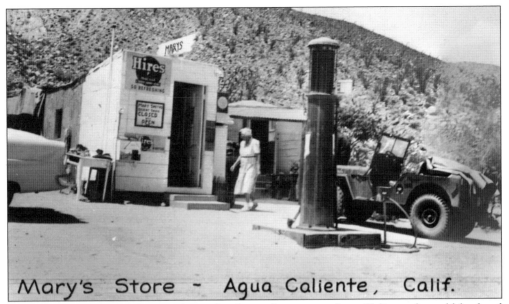

Mary's Store - Agua Caliente, Calif.

Health-seeker Mary Smith opened a six-foot-by-six-foot store at Agua Caliente that sold food and gas. An official branch of the San Diego County Library, it also lent books. The selection was limited to nonfiction works because "desert folk want[ed] factual and scientific reading, chiefly on the desert."

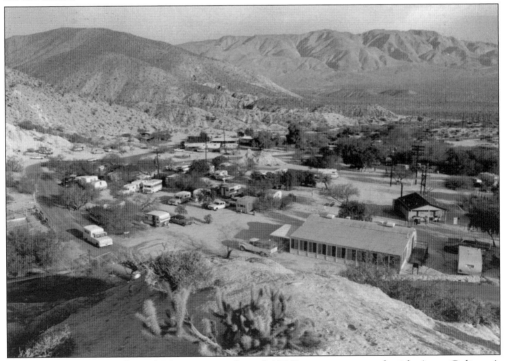

In 1948, the Bureau of Land Management leased 120.7 acres connected with Agua Caliente's mineral and hot springs to DPR for a park. Later that same year, DPR partnered with the State of California to lease an additional 640 acres. DPR continues to lease Agua Caliente County Park (shown here about 1970) in much the same ratio.

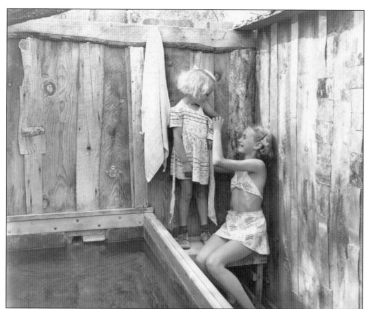

Early campers installed Agua Caliente's original bathhouses—photographed here pre-1948—with their own labor, at their own expense. "Don't go to Agua Caliente unless you are a real desert lover and are serious," warned the *Desert Magazine* in 1947. "It is distinctly no place for whoopee parties or the merely curious."

In 1964, DPR constructed a glass structure for Agua Caliente's 102-degree pool. The park also boasts an outdoor children's pool, sourced from a 90-degree spring, and another outdoor pool heated to about 82 degrees. In this 1972 photograph, ranger Sam Dennis reminds Mary Ann Calcott to wear a hairnet.

Ranger Mike Neal plays guitar at a "Wilderness Weekend" at Agua Caliente in the 1980s. Wilderness Weekends encouraged visits to different DPR parks each month. The Parks Society, dedicated to the promotion, assistance, and maintenance of DPR parks, presented the series. The 1982 Agua Caliente Desert Experience offered a desert-survival lecture, a campfire program on desert reptiles, and an astronomy lecture.

Indigenous Peninsular bighorn sheep inhabit the rocky slopes, cliffs, canyons, and washes of the Colorado Desert, including Agua Caliente Park. An endangered species, they are protected by law, and spotting the elusive animals in the park is a special occurrence. They are generalist herbivores who feed on a wide variety of desert plants, such as cacti, grasses, and shrubs. These rare mammals are San Diego County's official animal.

About three miles away from Agua Caliente, within Vallecito County Park, one can find an 1857 stage station for the San Antonio-San Diego Mail and the 1858 Butterfield Overland Stage. As roads and rail transport grew more reliable, stage travel lost favor; by 1888, Vallecito fell into disuse. Adventurers, such as Robert Allen Wilkin (center) in 1920, liked to explore the moldering building. (SA.)

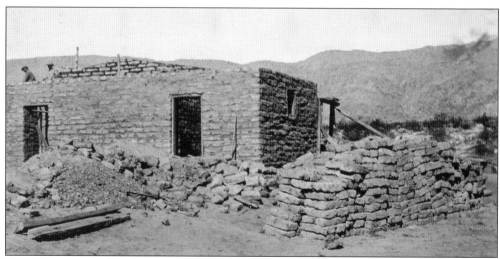

Preservationists, led by stage-travel enthusiasts Dr. Louis and Dolores Strahlmann, faithfully restored the Vallecito stage station in 1934 and 1935. They carefully followed original construction methods, plowing sod blocks out of a nearby marsh just as builder James Ruler Lassator had done. (Dolores did break with tradition to place 13 good-luck pennies on Vallecito's cornerstone.)

The Strahlmanns convinced Vallecito's owner, Christopher Franklin Holland, to donate the land and the building to the County of San Diego in 1934. Ten years later, an employee magazine celebrated the stage station's acquisition and revival. Restorers hoped to reconstruct a stagecoach repair shop and build a caretaker's residence on the property, but funding never materialized.

Old Vallecitos Stage Station, San Diego County

The ashes of Vallecito's earliest patented owner, James Mason, were interred there in 1949. Others lived at Vallecito before him, but Mason claimed its 160 acres in 1884 and then sold the acreage to Holland in 1888. Mason and Holland became good friends before Mason's death in 1929 (the plaque's dates are erroneous). Holland requested a monument (pictured here, in progress and completed) erected to Mason when the stage station underwent restoration.

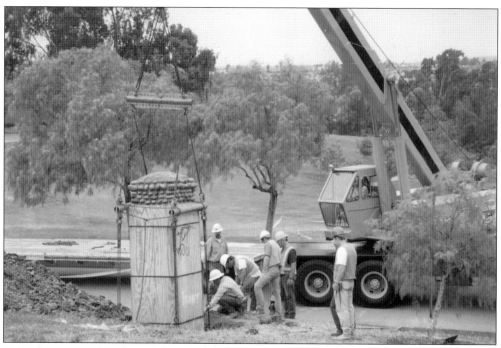

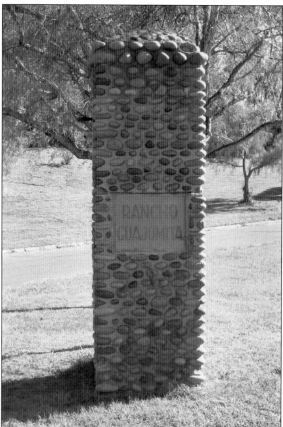

More cairns reside at Guajome Regional Park, approximately 40 miles north of San Diego. Two stone pillars dating from the 1930s occupied an area the California Department of Transportation dedicated to the expansion of State Route 76. The pillars, each weighing between 8 and 14 tons, were removed on June 10, 1997, brought across the highway, and cemented into the park (as depicted in this photograph) two days later.

The pillars originally marked the entrance to Rancho Guajomita, a now-defunct residential and agricultural complex. Rancho Guajomita fell on the 2,200-acre land grant known as Rancho Guajome, awarded by the Mexican government to Luiseño brothers Andrés and José Manuel. Rancho Guajome Adobe, featured in chapter seven, sits near the southern end of Guajome Regional Park, which itself encompasses 600 acres of the Rancho Guajome land grant.

DPR established Guajome Regional Park in 1973 by acquiring 378.26 acres of land for almost $2 million. Proponents hoped it would be like a Balboa Park for north-county San Diegans. Guajome Regional comprises some of the most variegated habitats found in any DPR park, with the wetlands of Guajome Lake (shown in this 1973 photograph) and Guajome Marsh. The park opened its campground on March 29, 1985.

The pre-DPR landowner who dredged and dammed Guajome Lake, Jerome Buteyn, did so to create a habitat for his exotic birds. His collection of over 3,800 birds—345 species among them—included swans that lived, uncaged, on the lake. Buteyn's "zoo" reached its heyday in the 1950s and thousands of people visited it each year. Buteyn's birds even appeared in the 1959 movie *Green Mansions* starring Audrey Hepburn. (SDHC.)

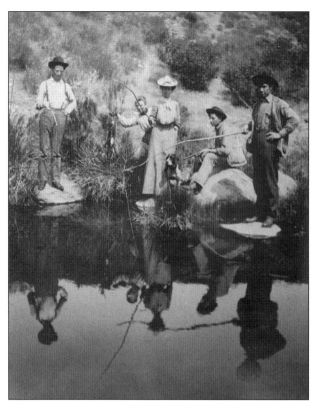

Another lake, Morena, was legendary in early-20th-century Southern California for its fishing, duck-hunting, and camping. Recreationists "carried [off] bass by the hundredweight." Fish-planting began in 1911 with stock from Lower Otay. In 1916, an assemblage that included Arctic grayling, crappie, salmon, and trout was re-homed from the US Fish Commission's exhibit at the Panama-California Exposition in Balboa Park.

DPR agreed to lease the acreage of Lake Morena Park from the City of San Diego in 1970. On May 12, 1972, the park opened. All 24 of its boats were rented by 8:10 a.m. That first weekend saw 89 boat rentals, 41 campsite rentals, and 1,510 anglers who caught several thousand catfish.

Lake Morena, the Parks Society thought, could be the site of a convenience store that would raise funds for DPR; the society solicited proposals for such a store. The society also, in 1980, started selling clothing featuring the department's name and its logo at the time: a red-tailed hawk flying over the rising sun. In this photograph, two women model T-shirts while ranger Maureen Schwartfager observes.

The devastating flood mentioned in chapter five occurred after the San Diego City Council hired Charles Hatfield to produce enough rain to fill Morena Reservoir. Charles and his brother Joel built a 20-foot tower beside Lake Morena from which to conduct their work, and rain started falling on January 5, 1916. A smaller replica of Hatfield's platform, used for interpretive programs, stood at the lake in the 1990s.

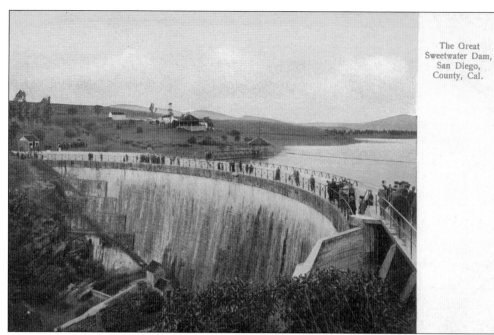

The Great
Sweetwater Dam,
San Diego,
County, Cal.

Hatfield's flood tested the dam at Sweetwater Reservoir, which today overlooks several tracts that compose Sweetwater Summit Regional Park. Establishing this park took years and involved 16 land acquisitions totaling 524.8 acres. In 1868, long before DPR became involved, the park land—and much of the surrounding area—was snapped up by investor brothers Levi, Warren, and Francis "Frank" Kimball. Frank, especially, wanted to develop Sweetwater Valley.

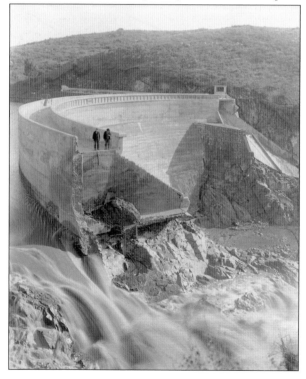

Frank Kimball's dreams of development depended on water. To that end, he built Sweetwater Dam to create a six-billion-gallon reservoir. The dam, which upon completion in December 1887 was the highest masonry arch dam in the country, was one of San Diego County's earliest tourist attractions. The 1916 flood only washed out its earth fill. The American Society of Civil Engineers declared the dam a national historic landmark in 2006. (SDHC.)

The *Evening Tribune* called Sweetwater Reservoir a "popular mecca for San Diego nimrods" (referring to hunters)—even Babe Ruth (standing) visited in 1927. Fishing enthusiasts also thronged to the reservoir. A special train transported downtown anglers for just 50¢, making Sweetwater the county's most popular freshwater fishing locale. Such recreation ended in 1941 when the US Navy began using the spot to conduct sonar tests. (SDHC.)

Before it was a campground, Sweetwater Summit held a dairy. Sweet Haven Dairy, established there in 1945 by Otto Rollin, at one time averaged the highest milk production in San Diego County. Otto's son Paul continued the business until he sold the site to DPR in 1975. The original Rollin family home is used as park staff housing, and historical feed troughs hide among the campsites.

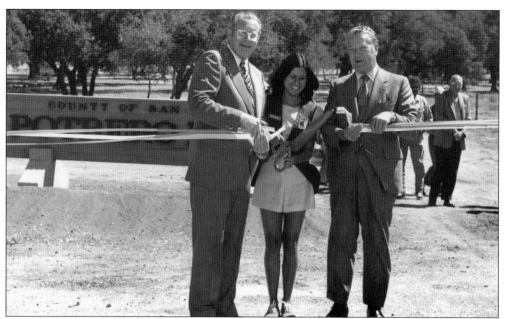

Potrero County Park once housed livestock, too—*potrero* means "paddock" in Spanish. The county parks and recreation commission, "after lengthy discussion" and a phone call to the library to confirm the meaning, decided on the name. DPR dedicated the park on September 14, 1972. Chair of the board of supervisors Harry Scheidle (left), rangerette Roxanne Leal, and Supervisor Henry Boney led the ribbon cutting.

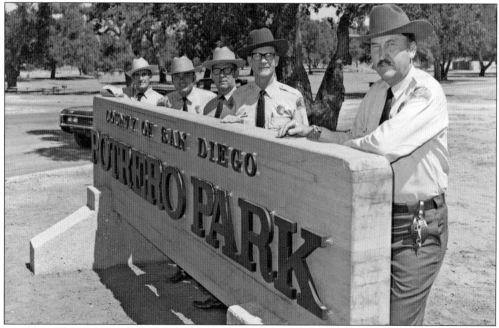

The land where Potrero Park is now located was homesteaded in the early 1880s by John Thomas English, a Civil War veteran. DPR picked up the real estate in 1963 for $35,000 and added more acreage to it in 1966. Located east of the city of San Diego and near the Mexico–United States border, Portero Park was a logical place in 1973 for DPR's first bilingual park ranger.

Seven

PRESERVATION IN PARKS

From its earliest years, DPR has worked to preserve San Diego County's natural and cultural resources and to interpret them to the public. Cletus Gardner worked with the county historic markers committee, placing landmarks at sites of historical significance. His hiring was, in part, a result of County Supervisor Walter Bellon's 1944 condensed history of the county park holdings.

DPR owns and operates two adobe ranch houses. The grounds of one, Rancho Peñasquitos, dating to 1823, were the first Mexican land grant. The other, Rancho Guajome, was one of the largest early adobes. Both ranch houses have been preserved and restored, following strict national and state standards, for the public to appreciate. Volunteer docents help with the history, interpretation, and furnishing of these house museums.

Besides these two major historic-preservation parks, DPR owns Heritage County Park, a collection of outstanding Victorian houses and a synagogue, and the Whaley House and associated Derby-Pendleton House. These buildings are located in Old Town San Diego. Other sites of historical interest portrayed here are the Bancroft Rock House and the remains of the Sickler Brothers Gristmill in Wilderness Gardens County Preserve. Upkeep of historic parks is a never-ending process. One must not only consider the special materials used in these structures, but also maintain accuracy to the building and the period. Many of DPR's properties hold historic-preservation status as national, state, or county landmarks.

As part of its mission statement, DPR, in conjunction with local cities and state and federal agencies, has instituted the Multiple Species Conservation Program (MSCP) to preserve San Diego's biodiversity. This model program, which started in south San Diego County and has expanded to other areas, works to acquire habitat acreage to protect endangered species as well as San Diego's native plants and animals. Careful conservation of natural areas, like the preservation of historic sites, works to improve San Diegans' quality of life.

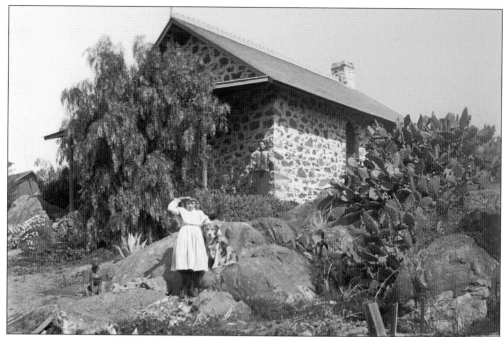

In 1885, San Francisco–based historian and publisher Hubert Howe Bancroft purchased the Rufus K. Porter farm of 180 acres in Spring Valley for $8,000. In the photograph above, taken about 1893, Lucy Bancroft and her governess stand with family dogs in front of the Bancroft rock house, which was mainly used as a guest cottage. Built between 1885 and 1888 by the Hinck brothers, east-county stonemasons, the rock house was located amidst huge boulders above a spring-fed reservoir. The County of San Diego added the rock-house property in 1992. DPR completed rehabilitating the historic building, with its decorative ridgeline and *metates* built into the interior corners, in 2010. The project received a 2013 California Governor's Historic Preservation Award. (Above, SDHC.)

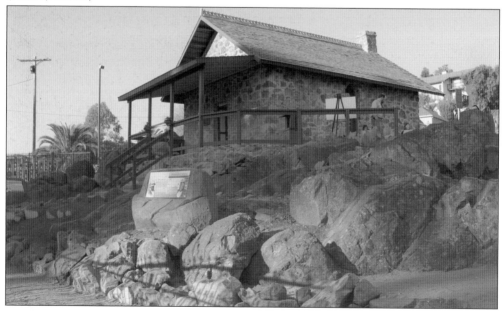

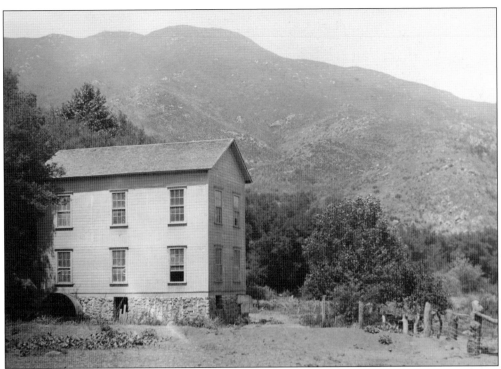

Wilderness Gardens County Preserve was once the home of Los Angeles newspaper publisher Elias Manchester Boddy. Horticulture and politics also interested Boddy. He deeded his Descanso Gardens to the County of Los Angeles. DPR acquired his Wilderness Gardens in 1973. Besides the remnants of Boddy's garden plantings, the preserve protects the remains of a historic gristmill. M.M. Sickler and his brother W.A. Sickler purchased land and built the Pala Mill along the San Luis Rey River in 1880–1881. This, the first gristmill in northern San Diego County, was important to the region's farms and ranches. The photograph above, taken in 1902, helps preserve the memory of the three-story, wood-over-stone building. All that remains of the gristmill are its rock foundation and cast-iron waterwheel. (Above, SDHC.)

Rancho Santa María de los Peñasquitos Adobe, the centerpiece of the first Mexican land grant within present-day San Diego County, stands at the east end of Los Peñasquitos Canyon County Preserve. Owned and administered jointly by the County and the City of San Diego, the preserve is a protected habitat in central San Diego. After developer Irvin Kahn agreed to sell the land, DPR began restoration work on the adobe and its outbuildings. The ranch land also served as a learning laboratory for archaeology students from 1980 onwards, and DPR operates the National Historic and Archaeological District at the site. The bottom photograph captures an archaeology field class in action north of the ranch house. Students record information, screen for artifacts, and work in test units.

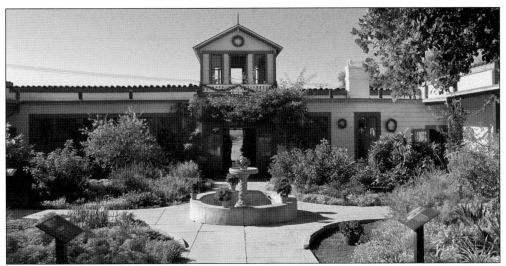

Rancho Guajome Adobe, home to the Couts-Bandini family, became County of San Diego property in 1973. The photograph below testifies as to the adobe's sadly deteriorated state. Restoration by DPR took place in the 1990s. The restoration meticulously conformed with the secretary of the interior's standards for historic preservation. The archaeology, restoration, and preservation work on this National Historic Landmark won numerous awards, chief among them a 1997 California Governor's Historic Preservation Award. The furnished, 28-room adobe, plus its chapel, outbuildings, and beautiful grounds, welcome visitors in north San Diego County for docent-led tours and special events.

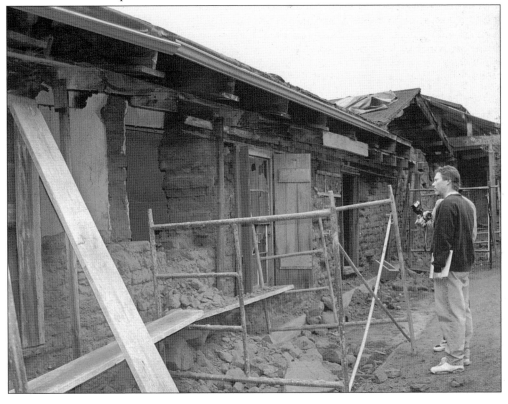

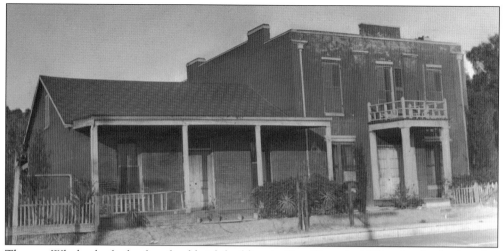

Thomas Whaley built the first fired-brick building in San Diego in 1857, using bricks from his own brickyard. In addition to a family home, the Whaley House served as a store, theater, and courthouse. The Whaley House is owned by the County of San Diego and has been operated as a house museum since 1960. The Save Our Heritage Organisation (SOHO) took over its management and operation in 2000. Ongoing maintenance of the landmark requires specialized expertise. The photograph below from 2008 shows work to restore the porch to its original design. Archaeology projects such as the excavation of the Whaley rainwater cistern uncover valuable information about the Whaleys and early San Diego.

Heritage County Park preserves fine examples of Victorian architecture from the late 1880s and the 1890s. Pictured above, from left to right, are the Sherman-Gilbert, Bushyhead, and Christian Houses. Also in the park are the Senlis Cottage, McConaughy House, and Burton House. In addition, the city's first synagogue, Temple Beth Israel, is available for weddings and other special occasions. The buildings were moved to the site, with the help of the newly formed SOHO, for preservation and restoration starting in 1971. The image below captures the Christian House being moved down Juan Street in August 1976. The Bushyhead House has already been moved next to the Sherman-Gilbert.

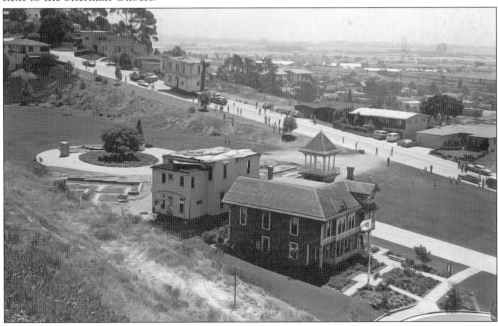

In 1996, DPR marked its 50th anniversary with a celebration at Heritage Park. Second from left in the first row is Director Robert Copper, who retired that year. Next to Copper is future director Susan Hector (holding certificate). In the center of the front row, attired in a suit, is Michael Kemp, who took over from Copper.

In addition to historic preservation, DPR is committed to a program of habitat protection. The Multiple Species Conservation Program (MSCP), initiated in October 1997 by Supervisors Dianne Jacob and Pam Slater, is recognized as a national model for preserving precious open-space lands. This land, Daley Ranch in Jamul, was obtained in 2001 to be dedicated open-space habitat.

Eight

OLDER PARKS WITH NEWER ELEMENTS

DPR never stops working to improve its parks. Preserving the land for the public and for future generations takes dedication from a host of professionals—a process that can require years of planning. This chapter introduces some of DPR's older parks and their significantly upgraded elements: San Elijo Lagoon Ecological Reserve, Sycamore Canyon/Goodan Ranch County Preserve, El Monte County Park's Flume Trail, and the County Administration Center's Waterfront Park.

San Diego County is blessed with a number of lagoons. Motorists traveling on Interstate 5 are treated to a view of these coastal wetlands. San Elijo Lagoon is one of these gems. Once a seasonal home to indigenous peoples, San Elijo is a popular park with many family activities.

Sycamore Canyon, with its Goodan Ranch headquarters, is a favorite of hikers and mountain bikers. In 2003, this park was severely hit by the Cedar Fire. DPR built an environmentally sensitive visitor center to honor the land and its history. Through the efforts of volunteers, the forgotten town of Stowe, once a part of Sycamore Canyon, has been recognized.

The San Diego Flume contributed to significant agricultural, industrial, and residential growth during the late-19th and early-20th centuries. Part of the route of the flume in Lakeside has been graded, cleared, and made into a trail, a large piece of which lies inside El Monte Park. Outdoor enthusiasts can explore the story of the flume as they traverse the slope cut where it sat over 125 years ago.

The San Diego County Administration Center (CAC) was the seat of City and County of San Diego governments for more than a quarter century. Because both governments operated out of it, the CAC was originally known as the San Diego Civic Center. When it was built, the CAC received international attention for using steel pilings to bear lateral stresses for the first time in structural engineering history. Now, Waterfront Park surrounds the historic building and provides a central city park for citizens.

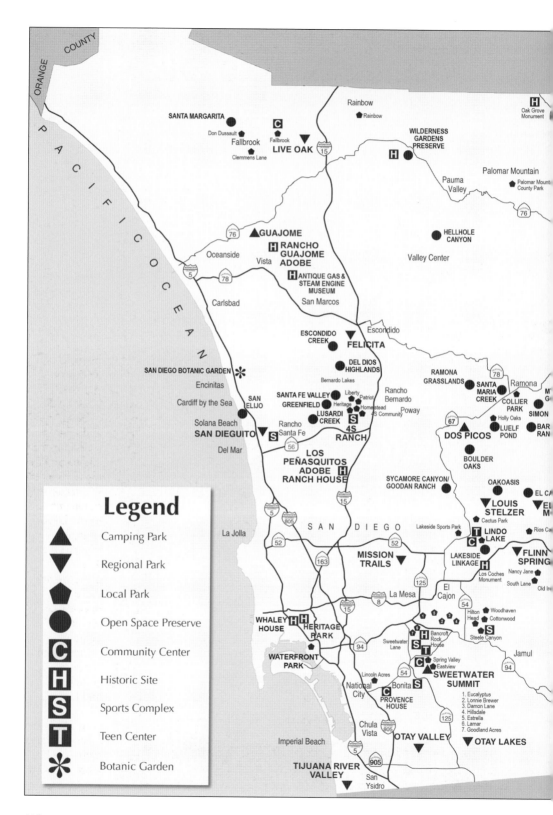

ORANGE COUNTY

PACIFIC OCEAN

SANTA MARGARITA
Don Dussault
Fallbrook
Clemmens Lane

Fallbrook
C
LIVE OAK
▼
15

Rainbow
Rainbow

Oak Grove
Monument
H

**WILDERNESS
GARDENS
PRESERVE**
H

Pauma
Valley

Palomar Mountain
Palomar Mount
County Park

76

**HELLHOLE
CANYON**

Oceanside
▲**GUAJOME**
**H RANCHO
GUAJOME
ADOBE**
Vista
**H ANTIQUE GAS &
STEAM ENGINE
MUSEUM**
San Marcos

Valley Center

76

Carlsbad

Escondido
**ESCONDIDO
CREEK**
▼
FELICITA

SAN DIEGO BOTANIC GARDEN ✳

Encinitas

Cardiff by the Sea
**SAN
ELIJO**

**DEL DIOS
HIGHLANDS**
Bernardo Lakes

**SANTA FE VALLEY
GREENFIELD**
Liberty Patriot
Heritage
Homestead
4S Community
Rancho
Bernardo
Poway

**RAMONA
GRASSLANDS**
**SANTA
MARIA
CREEK**
Ramona
78
M
G
**COLLIER
PARK**
SIMON
Holly Oaks
**LUELF
POND**
**BAR
RAN**

Solana Beach
SAN DIEGUITO
▼
Rancho
Santa Fe
S
**LUSARDI
CREEK**
S
**4S
RANCH**

67
DOS PICOS
▲

Del Mar
56

**LOS
PEÑASQUITOS
ADOBE
RANCH HOUSE**
H

**BOULDER
OAKS**

**SYCAMORE CANYON/
GOODAN RANCH**

OAKOASIS
EL CA

15

**LOUIS
STELZER**
▼
**EL
M**

La Jolla
805
5
SAN DIEGO
Lakeside Sports Park
Cactus Park
Rios Ca

52
52
**LINDO
LAKE**
T
C

**FLINN
SPRING**
▼

163
**MISSION
TRAILS**
▼
**LAKESIDE
LINKAGE**
H
Los Coches
Monument
Nancy Jane
South Lane
Old In

125
El
Cajon
8
La Mesa
54
Hilton
Head
Woodhaven
Cottonwood

15
**WHALEY
HOUSE**
H H
**HERITAGE
PARK**
94
Sweetwater
Lane
H Bancroft
Rock
House
T
S
Steele Canyon
Jamul
94

**WATERFRONT
PARK**
Lincoln Acres
54
C
Spring Valley
Eastview
**SWEETWATER
SUMMIT**
▲

National
City
Bonita
S
1. Eucalyptus
2. Lonnie Brewer
3. Damon Lane
4. Hillsdale
5. Estrella
6. Lamar
7. Goodland Acres

C
**PROVENCE
HOUSE**
Chula
Vista
125

Imperial Beach
5
OTAY VALLEY
▼ **OTAY LAKES**

**TIJUANA RIVER
VALLEY**
905
San
Ysidro

Legend

▲ Camping Park

▼ Regional Park

⬟ Local Park

● Open Space Preserve

C Community Center

H Historic Site

S Sports Complex

T Teen Center

✳ Botanic Garden

Warner Ranch Stage Station Marker

Warner Springs

OLD SPRINGS/PEG LEG

S22

Borrego Springs

79

S2

Ocotillo Wells

78

SANTA YSABEL
EAST

A YSABEL
VEST

VOLCAN
MOUNTAIN

78

Julian Jess Martin

Julian H S
Pioneer
Museum

78

WILLIAM
HEISE 79

Cuyamaca

VALLECITO

H

AGUA
CALIENTE

S2

S1

Mount Laguna

Descanso

8

S Pine Valley

Alpine

Pine
Valley

79

8

LAKE
MORENA

94

Campo

POTRERO

H CAMPO STONE STORE
AND MUSEUM

Jacumba

188 Tecate

M E X I C O

IMPERIAL

COUNTY

"A parks and recreation system that is the pride of San Diego and a national model for park and recreation organizations" is a vision statement in the DPR strategic framework. The department's parks, open-space preserves, community centers, teen centers, sports complexes, and historic sites as of early 2017 are labeled on this map—and more parks are in progress.

111

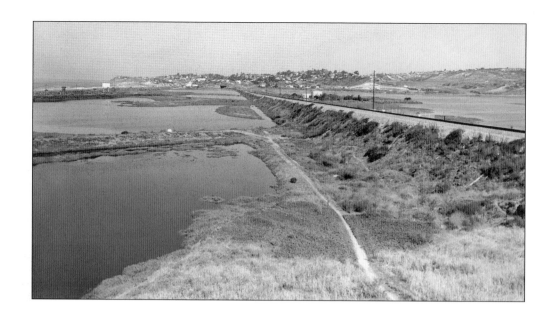

When the 1769 Spanish expedition came through San Elijo, they named the area "San Alejo." Trip diarists noted the village of friendly Indians and evidence of salt-gathering near the large inlet from the sea. San Elijo is a coastal wetland between Solana Beach and Encinitas with diverse habitats. As early as 1929, the board of supervisors considered a seaside park here after Frank Cullen of Cardiff offered 10 acres. By the late 1960s, private builders planned major construction. Citizens organized to save the lagoon and have continued protecting it. Now, the San Elijo Lagoon Conservancy, the State of California, and the County of San Diego manage the area. A new nature center was built in 2009, as seen below. It is owned and operated by DPR and is an award-winning, LEED-certified building.

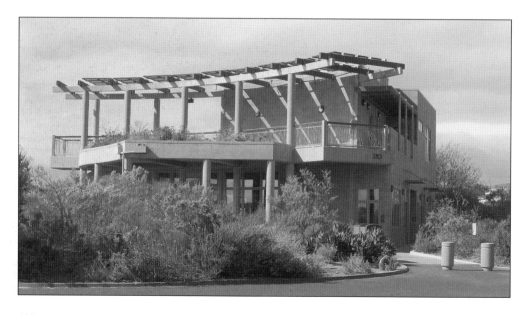

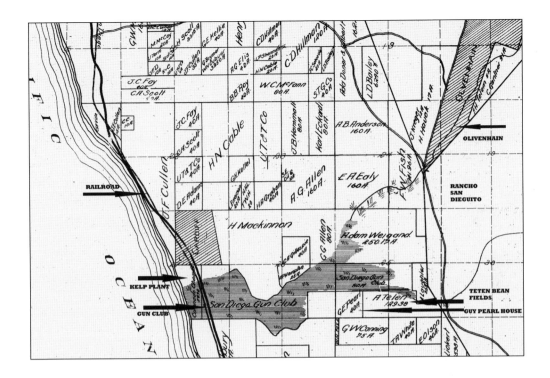

This plat map, dating from around 1910, identifies some of the early locations around San Elijo Lagoon. Mexican-era ranchos San Dieguito and Los Encinitos were nearby. A short-lived kelp-processing plant operated by the Coronado Chemical Company of Arizona harvested kelp as a source of material for explosives. Some pillars from the building, located north of the lagoon, can still be seen. A gun club had facilities and a clubhouse on the south side of the lagoon. The foundation of the Guy Pearl house is along the lagoon trails, among eucalyptus trees. The farmers of Olivenhain, such as the Tetens, who also had land near the lagoon, dry-farmed lima beans and black-eyed peas. Here, members of the Teten family work with a lima-bean threshing machine. (Below, RB.)

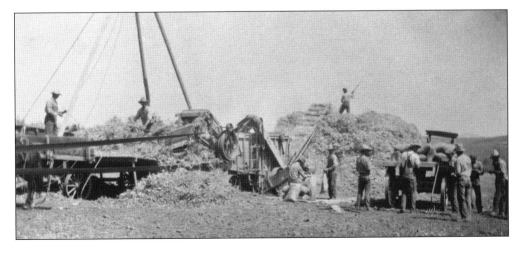

Sycamore Canyon County Preserve is managed by multiple agencies and protected by the Multiple Species Conservation Program. Kumeyaays found the area desirable. Some lumbering took place in the 1870s, and the community of Stowe was sparsely settled later. Once, the canyon was targeted for a series of contested projects—a prison, an off-road vehicle park, and a mobile-home park. DPR first held surplus land here in 1963.

The one-room, wooden Stowe Schoolhouse in the northern end of Sycamore Canyon opened in 1890. At one time, enrollment reached 19 students. Teachers changed almost yearly. The school was sold in 1911 and torn down. Stowe had a post office from 1889 to 1905 on the San Diego-Escondido mail route. Some families, many of German and Prussian descent, produced dairy products, kept bees, grew fruit, and raised cattle. (SDHC.)

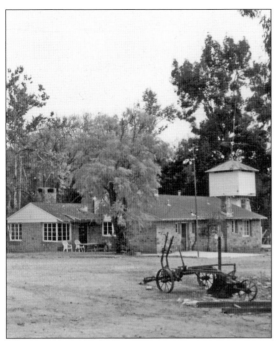

Goodan Ranch, located in Sycamore Canyon, is the headquarters for the preserve. The land was acquired in 1938 by Roger and May Goodan. May was a Chandler, founders of the *Los Angeles Times*, and the ranch served as a retreat for the Los Angeles–based couple. They built a main ranch house of stone and wood with a two-story tank house next to it. Military equipment was stored on the ranch during World War II for nearby Camp Elliott. Interestingly, the original Navajo Code Talker School was located at that camp. The upper-right photograph displays the destruction of the 2003 Cedar Fire, which completely burned the preserve and the house. The visitor center, appearing on this page in a 2013 photograph, was built across from the original house. The building is an eco-friendly, award-winning facility.

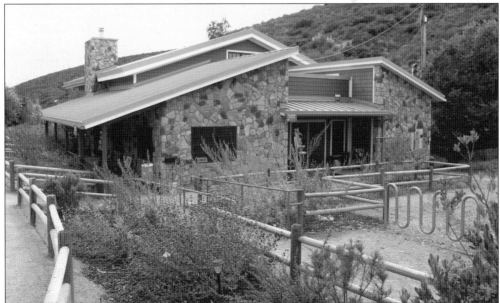

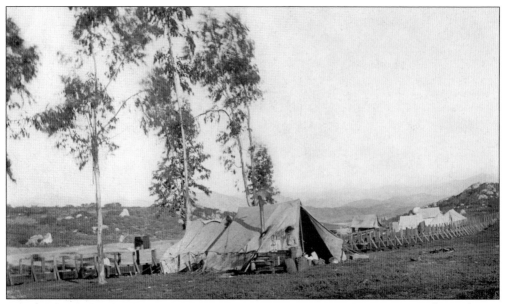

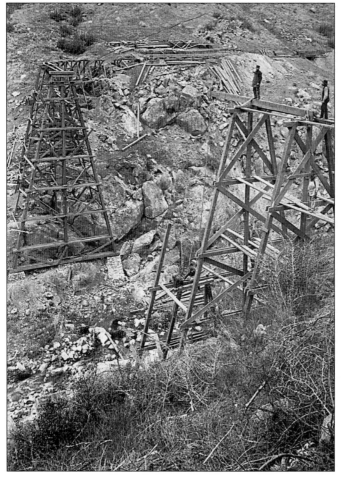

Constructing a flume drew hundreds of laborers to San Diego's east county, where they dynamited rocks, dug tunnels, and moved boulders, generally preparing the terrain for carpentry and flume-laying. Temporary camps (pictured in 1889) were erected so these men could live and sleep on site. Tents sufficed for most, although enough workers wanted to sleep indoors that a local hotel added 40 rooms to accommodate them. (SDHC.)

To cross the gullies and ravines in its path, the flume required redwood trestles built of nine million board feet of lumber, the first shipload of which arrived on June 7, 1887. The longest trestle measured 1,774 feet, and the highest topped 80 feet. Some of the trestles were the largest of their kind in the state. This is the South Fork Trestle, about 1887. (SDHC.)

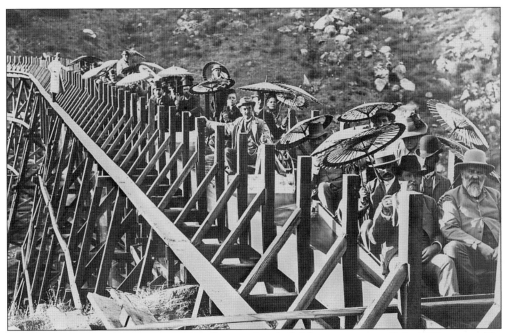

In June 1888, when the flume was partially completed, California governor Robert Waterman (far right) and 32 "excursionists" rode down a nine-mile section. Their trip took roughly three hours. A newspaper reported that the governor was "especially enthusiastic over [his] flume voyage." Sources often mistakenly claim that this photograph and others like it were taken on the flume's opening day, February 22, 1889. (SDHC.)

Anticipation built further when San Diego's 1888 Fourth of July parade showcased "a full-size section of the great San Diego flume, drawn by ten powerful horses." "A source of wonderment to thousands," it was "one of the most interesting features of the parade." Interest piqued and San Diegans snatched up a special "Extra Flume Edition" of the *Union*—it was "exhausted by an unprecedented demand" and had to be reprinted. (SDHC.)

Keeping the flume watertight necessitated constant wedging and caulking. Creative alternatives were attempted, including lining the wooden trough with gunite (seen in this photograph, probably from 1919), a material commonly used in swimming pools. This had limited success; leaks and rot still weakened the flume's trestles. Additionally, evaporation was a problem. The flume could not deliver what it promised, and people turned on it. (HWD.)

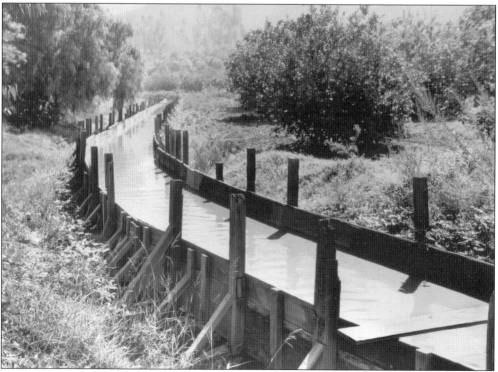

Even with repairs and ancillary measures such as pumping groundwater into it, the flume system (running here around 1920) rarely had this much water flowing through it. The last year the flume, as originally designed, was in service was 1925. By necessity, the open flume was gradually replaced by siphons, covered conduit, and pipelines. In November 1937, the last remaining portion of original redwood flume was retired. (HWD.)

Where it was not supported on trestles, the flume ran along a bench cut in the mountainside. The cut was 12 feet wide, constructed upon solid earth or rock, with no fills or made ground—except solid-stone masonry—utilized. This masonry, composed of stacked granite cobbles, stabilized the downslope edge of the flume. (SDHC.)

Ultimately, the flume had no hope of turning a profit. It was dismantled, the wood salvaged, and little remains of the first large-volume steady water source for the City of San Diego and its neighboring communities. Though the flume itself no longer exists, its bench cut, tunnels, and rock walls (built approximately 1887) are clearly visible to present-day hikers in El Monte Park and elsewhere.

The minutes of a San Diego City Council meeting on June 18, 1850, first suggest a bayside city-county civic center. The idea resurfaced in 1908 with John Nolen's plan for the city. Great Depression–era measures to stimulate economic recovery allowed the concept to take shape. Architects William Templeton Johnson, Richard Requa, Samuel Hamill, and Louis Gill designed plans such as this one from 1934.

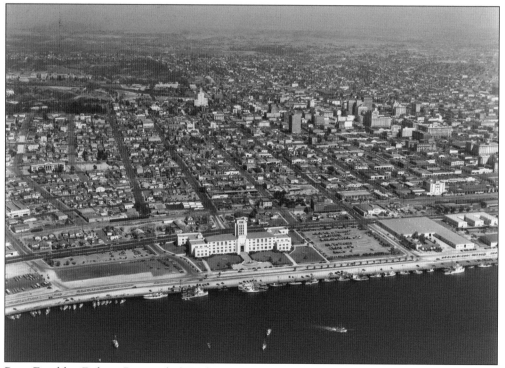

Pres. Franklin Delano Roosevelt (FDR), in town for the 1935 California Pacific International Exposition, visited the site of the prospective civic center. Just one week after his personal tour, FDR approved $989,528 for the building's construction. Ground broke on December 5, 1935. One can see how the edifice's design changed from the previous sketch to a more practical concept with a tower modified to meet aviation height demands. (SDHC.)

Negro Civic & Economic League
of San Diego City & County

MEETS FIRST THURSDAY OF EACH MONTH

San Diego, Calif., April 16, 1935

The Honorable Board of Supervisors of
San Diego County
San Diego, Calif

Gentlemen:

A largely attended Mass Meeting of
colored citizens of San Diego assembled on the
evening of April 15th, 1935, and unanimously
voted to request your Honorable Body to insert
a clause in the contract for the erection of the
proposed City - County Civic Center, that there
be no discrimination in the employment of indi-
viduals because of race or color.

We further request that it be specifically
stated that negroes shall be given a proportionate
share of the employment during the construction

SIGNED

J. H. Brown
Bert Ritchey
J. Buchanan
C. H. Hampton
James P. Tate

239-9425

431 J St.

FILED
APR 23 1935
J. B. McLees, County Clerk
By *Helen Burch*, Deputy

The money Roosevelt approved came from the Works Progress Administration (WPA). The WPA, formed in 1935, was one of FDR's New Deal programs to produce economic relief and recovery. In a time of worldwide financial depression, the WPA provided work for millions of people. In 1935, over 15,650 people in San Diego County were employed on WPA projects, the 300-odd men who worked on the CAC among them. The Negro Civic and Economic League petitioned the county board of supervisors for inclusion in this workforce—here is a copy of their missive.

FDR's prior involvement with the CAC led to his ready acceptance of an invitation to dedicate it. On July 16, 1938, the president greeted the biggest downtown crowd in San Diego's history—25,000 people. Paralyzed by illness, FDR could not leave his car to deliver a speech, so workers built a ramp that would allow the presidential automobile to drive right up to a microphone in front of the building.

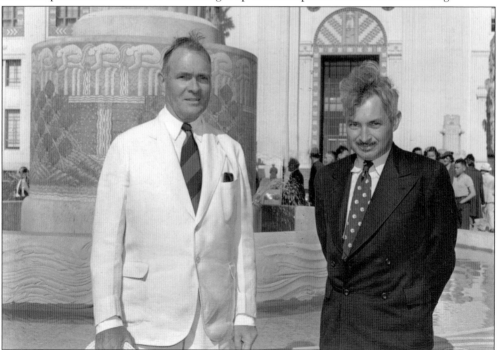

Another celebration occurred on June 10, 1939, when a statue, *Guardian of Water*, was unveiled outside the CAC's west entrance. Sculptor Donal Hord (right) stands before his statue with CAC architect William Templeton Johnson. Hord studied sculpture under Anna Valentien, a student of Auguste Rodin, at San Diego Evening High School. (SDHC.)

Guardian of Water began life in 1937 as a 22-ton slab of silver-gray granite, quarried for about four days in Lakeside before it could be loaded onto a truck and transported to Hord's studio in Pacific Beach. The statue was commissioned by the Federal Art Project, the visual-arts arm of the WPA. (Baker.)

Once the stone assumed Hord's desired form—a pioneer woman shouldering a pot of water—the 12-foot-3-inch statue could take her post and symbolize San Diego's guardianship over one of its most precious resources—water. The figure stands atop a mosaic-covered drum (see photograph with Hord and Johnson on page 122), designed by Hord and continuing his water motif. Kneeling nudes, representing clouds, pour water over a dam and into an orchard. (Baker.)

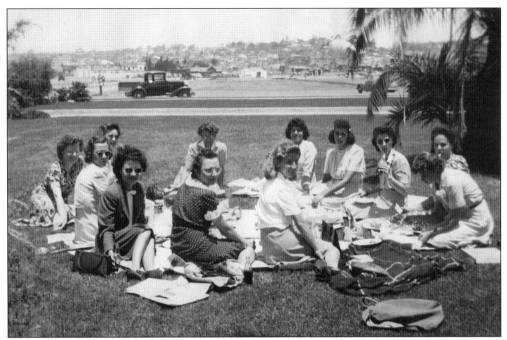

Employees from the San Diego County Education Department enjoy lunch outside the civic center in this 1942 photograph. Because of the war, picture-taking was banned along San Diego's waterfront, so they had to sneak this shot! Workers for the City and County of San Diego shared the building until 1964, when the City of San Diego began relocating to new administration buildings. By 1967, the County of San Diego was the sole owner of the renamed County Administration Center. (SDHC.)

The tradition of having a Roosevelt at CAC milestone events continued when, in 1988, FDR's eldest son, James (immediately left of the plaque), spoke at the festivities for the building's 50th anniversary and recent addition to the National Register of Historic Places. James reminded listeners that, to his father, the CAC embodied the United States' effort to arise from the Great Depression.

The days of asphalt and grass encircling the CAC were numbered when, in 2002, the board of supervisors approved $44.2 million to transform eight acres of parking lots into Waterfront Park. Construction of an underground parking garage, an 830-foot-long fountain and wading pool, and other amenities began in 2011. With the new park, the CAC finally has surroundings befitting its status as "the jewel on the bay."

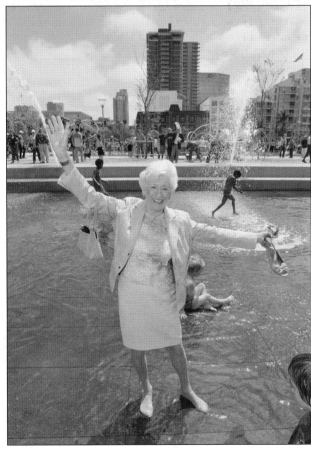

The Roosevelt family continued to be involved with the CAC, with FDR's daughter-in-law Mary Roosevelt attending the dedication of Waterfront Park in 2014. Mary, James Roosevelt's widow, spoke about the "strong connections" her husband and father-in-law each had to San Diego, adding, "I am so happy to continue my family relationship with your city, on this very special occasion." (PN.)

DPR's history is built around parks, but that history exists because the people who wore the patches and badges of the department created, operated, maintained, and expanded those parks—and those people continue to do so today. It is a group that contains not just rangers, but also lifeguards, maintenance workers, administrators, tree trimmers, support staff, rangerettes, volunteers, and others, all working tirelessly to help DPR fulfill its mission to "enhance the quality of life in San Diego County by providing opportunities for high-level parks and recreation experiences and preserving regionally significant natural and cultural resources."

INDEX

DISCOVER THOUSANDS OF LOCAL HISTORY BOOKS FEATURING MILLIONS OF VINTAGE IMAGES

Arcadia Publishing, the leading local history publisher in the United States, is committed to making history accessible and meaningful through publishing books that celebrate and preserve the heritage of America's people and places.

Find more books like this at
www.arcadiapublishing.com

Search for your hometown history, your old stomping grounds, and even your favorite sports team.

Consistent with our mission to preserve history on a local level, this book was printed in South Carolina on American-made paper and manufactured entirely in the United States. Products carrying the accredited Forest Stewardship Council (FSC) label are printed on 100 percent FSC-certified paper.

MADE IN THE
USA